KIRKCALDY
THROUGH TIME
Walter Burt

D1419840

AMBERLEY PUBLISHING

Acknowledgements

Most of the older images used in the book are from my own collection. The modern photographs were taken by me between February and April 2013. Other images were supplied from friends via 'Facebook', especially 'Kirkcaldy Photos'. Other individuals who have contributed include Brian McDevitt, John Sinclair, Claire Pendrous, Robert Dickson, Terence Scott, Paul Redmond, Rosalind Davidson, Michael Laing and Michael Mather.

I apologise if I have omitted any names by mistake.

I must thank my wife, Lisa, and my children, Helena and Callum, for the seemingly endless days of neglect towards them, as well as the days of encouragement from them.

Dedicated to Lisa, Helena and Callum

First published 2013

Amberley Publishing
The Hill, Stroud
Gloucestershire, GL5 4EP

www.amberley-books.com

Copyright © Walter Burt, 2013

The right of Walter Burt to be identified as the Author of this work has been asserted in accordance with the Copyrights, Designs and Patents Act 1988.

ISBN 978-1-4456-1641-4
E-book ISBN 978-1-4456-1660-5

British Library Cataloguing in Publication Data.
A catalogue record for this book is available from the British Library.

Typeset in 9.5pt on 12pt Celeste.
Typesetting by Amberley Publishing.
Printed in the UK.

Introduction

The origins of Kirkcaldy can be traced back to the eleventh century when it was given as a gift to the Dunfermline Church by King Malcolm III. Whilst under the control of the Monks from Dunfermline Abbey, a house of some description was possibly built as a residence for the Abbot of Dunfermline when visiting the area. This may well be the origins of 'Abbotshall'. The name 'Kirkcaldy' also has religious origins as it means 'Kirk of the Culdees', 'Culdee' being an anglicised version of *Céli Dé* which itself means 'client or companion of God'.

Because of its location, Kirkcaldy, and its neighbour, Dysart, were always going to be good places from which to trade by sea. After a charter was granted by King David II in the fourteenth century, Kirkcaldy prospered, and by the sixteenth century it was considered to be an important trading port. Trading contracts existed with the Baltic nations, the Low Countries, England and Northern France.

In 1644, a charter issued by King Charles I, granted royal burgh status and led to full independence for the town. As a gesture, the king gave 8.12 acres of common muir suitable for 'bleaching of linen, drying of clothes, recreation and perpetuity' to the town.

Kirkcaldy grew along the sea front from the harbour near the mouth of the East Burn, and gradually extended to the Tiel or West Burn. This is why the town got the nickname of 'The Lang Toun'. It never grew inland further than a quarter of a mile during this time. It grew to be the largest town in Fife and was the administrative centre of the county. During the seventeenth century, Kirkcaldy's shipping, thought to number about 100 vessels, suffered many losses when Cromwell occupied the town during the civil war. After the civil war ended, trade began to pick up again. A new wet dock and pier was built at the harbour in the mid-1840s to help the town cope with the increasing imports of flax, timber and hemp as well as the export of coal, salt and linen. The major industries during this period were flax spinning and linen weaving. It was also around this time that Michael Nairn, a local canvas manufacturer, took out a licence on Frederick Walton's patent for the production of floorcloth, and opened a factory in nearby Pathhead. In 1876 when the patent expired, Michael Nairn and the other floorcloth manufacturers began the manufacture of linoleum, a product that has ever since been associated with the town. 1876 was also the year that the boundaries of the royal burgh were extended. The town absorbed settlements in Linktown in the parish of Abbotshall, Invertiel in the parish of Kinghorn, and Pathhead, Sinclairtown and Gallatown in the parish of Dysart. These former communities had at one time been forbidden to sell their goods in Kirkcaldy.

The twentieth century saw major changes to Kirkcaldy and its surroundings with another expansion during the 1950s and 1960s. New housing estates were springing up which began to extend Kirkcaldy further inland, to the north-west. A redevelopment of the town centre was to follow in the 1960s and 1970s which destroyed a lot of the old High Street. The population had reached its peak in 1961 when there were 53,750 Langtonians living in the town. It was expected to rise further still, but the decline of the linoleum industry in the mid-1960s saw a decline in the population to almost 48,000 by the early 1980s. The population of the town at present is nearly 49,000. The decline of the linoleum industry also had a severe effect on the harbour, which closed in 1992. In 2011, it re-opened again to allow cargo vessels to bring in wheat for the local Hutchison's flour mill next door. This allowed a quarter of the company's lorries to be removed from the ever-increasing congestion on Britain's roads.

Coal has also played an important role within Kirkcaldy. Approaching the town from the south-west, the first place you would have come across was the mining complex at Seafield colliery. Opened in 1960, it was said to have a life of 150 years, but closed only twenty-eight years later in 1988. Coming from the north-east, the visitor to Kirkcaldy would have come across the Frances colliery at Dysart, known locally as the 'Dubbie' pit. It, too, closed in 1988 in the aftermath of the miners' strike at the time.

Today, Kirkcaldy is still the principal town in central Fife, although nowadays, like other towns of similar size, service industries are the main employers. The town still boasts three parks; Beveridge Park at the west of the town, Ravenscraig Park to the east, and Dunnikier Park to the north-west. April each year sees the arrival of the annual Links Market, the longest street fair in Europe. Officially recorded as having started in 1304 as a farmers' market, it is now a pleasure-orientated event with stalls, dodgems, carousels and other thrill-seeking rides – a good family fun day out. Among other attractions to be found in Kirkcaldy, we find the Museum & Art Gallery near the town's war memorial. Virtually across the road, you will also find the Adam Smith Theatre. The theatre plays host to theatrical and musical productions as well as showing a selection of commercial films. There are other landmark buildings to be found in the town and these will be seen through the pages of this book.

The most famous of Kirkcaldy's sons was the social philosopher and economist Adam Smith, who wrote *The Wealth of Nations* at his mother's house at 220 High Street around 1765–1767. Other famous Langtonians include Robert Adam, a renowned eighteenth-century architect; former provost Michael Beveridge and Michael Nairn, who was famous for the production of linoleum.

In compiling this book, I made a start at Seafield as it was the first place I arrived at, and being the 'Lang Toun' it seemed to be an obvious starting point. I then decided to travel to some of the places along the inland areas on my way to Dysart. Following on from there, it was then natural for me to travel back towards the Seafield end, but taking in some of the places along the High Street and Esplanade. I hope it is an easy enough route to follow.

I was fairly surprised when I saw at first hand how many of the places had changed quite radically, yet, in the next place I visited, it seemed as if time had stood still. What I experienced whilst compiling this book, was the rich variety that Kirkcaldy has to offer in the form of its heritage. I found things out that I never knew about the town, and there is probably a whole lot more to be learnt. My advice to those who are interested in the town – just have a good walk through the streets and parks, take in the surroundings and enlighten yourself!

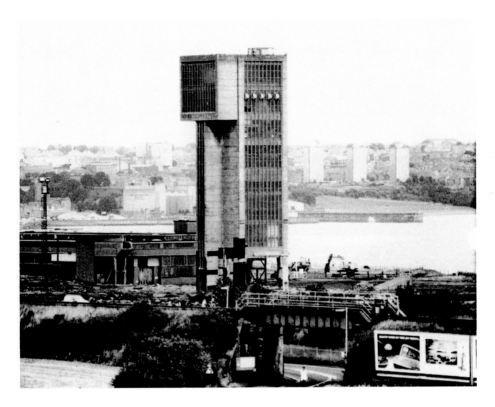

Seafield Colliery

One of the towers housing the winding gear at Seafield Colliery is seen here just prior to demolition during September 1989. The colliery was opened in 1960, and despite claims it had a lifespan of about 150 years, it closed only twenty-eight years later in 1988. As can be seen, the former colliery site is now a vast housing estate.

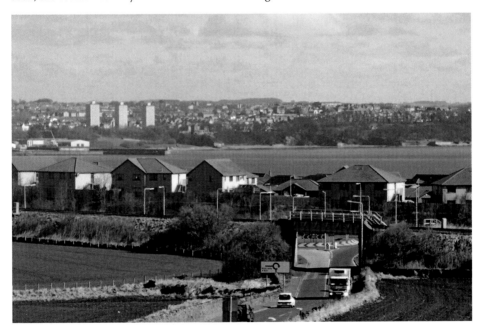

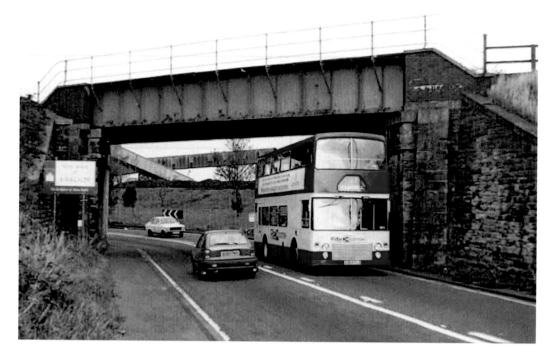

Seafield Railway Bridge

This railway bridge at Seafield carries the east coast main line and has had a repaint in recent years. The 'Welcome to Kirkcaldy' sign has also been updated and displays the legend 'The Lang Toun' as well as proclaiming to be a twin town of the German city of Ingolstadt. Houses of the new Seafield housing scheme, can be clearly seen below the bridge structure.

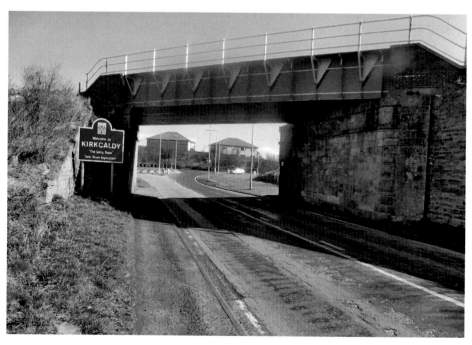

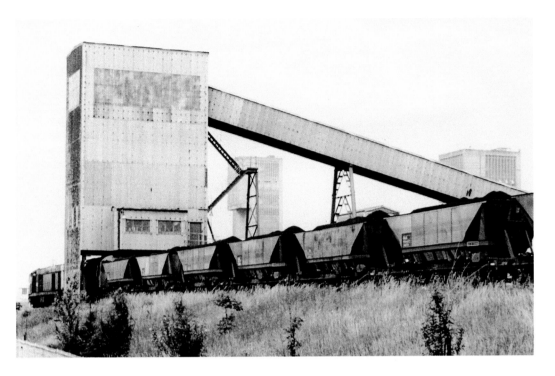

Seafield Colliery

This was the coaling tower that enabled the railway wagons to be filled with coal before their journey down the coast to Longannet power station. The coal was carried up a conveyor belt system to near the top of the tower and dropped into the waiting wagon below. The embankment is still there, but again, the new housing scheme dominates the area.

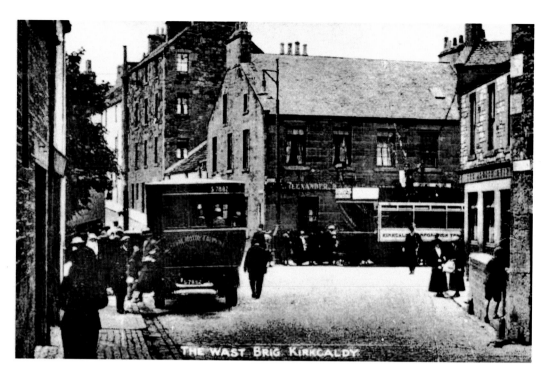

The Wast Brig

This was the southernmost terminus for the Kirkcaldy tramway system. It is at the end of Link Street, at the town's west bridge over the Tiel burn. (The old postcard proudly states 'The Wast Brig'). The Starks Bar, on the right of both images, is the only building in the area to remain standing for the last century or so, but the area is much less busy nowadays.

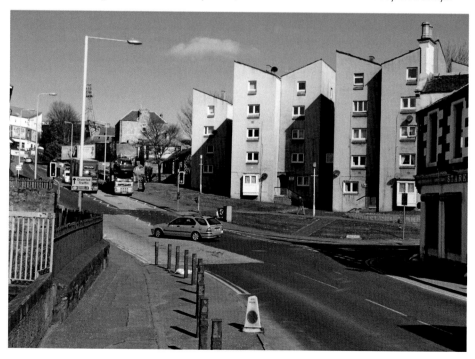

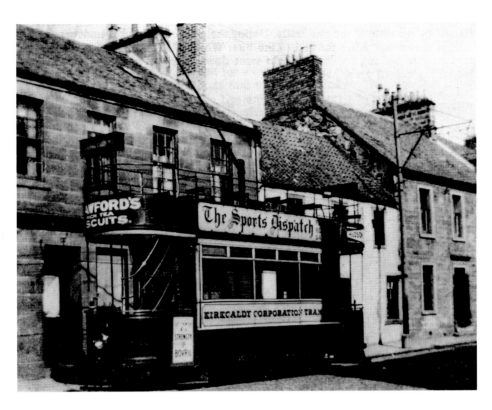

Links Street Tram Terminus

A better view of the buildings at the tramcar terminus at the southern end of Links Street. The general area now looks more open and less claustrophobic than as shown in the older images. This part of Kirkcaldy is also known as Linktown.

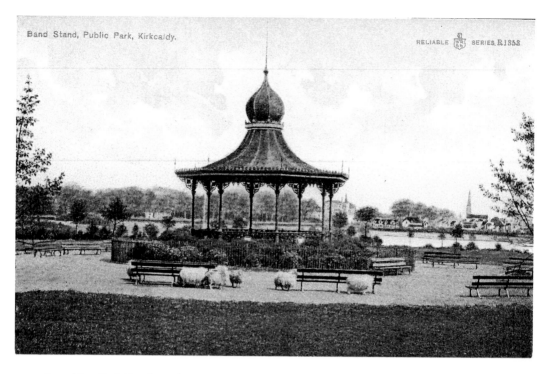

Beveridge Park Bandstand

Beveridge Park was gifted to the people of Kirkcaldy from former provost Michael Beveridge in 1890. It was formally opened on 24 September 1892 in front of a crowd of around 10,000. The ornate bandstand was a focal point for the opening day ceremony and was centrally located within the park. The bandstand was eventually demolished in 1956. A small seated area can now be found where the bandstand once stood.

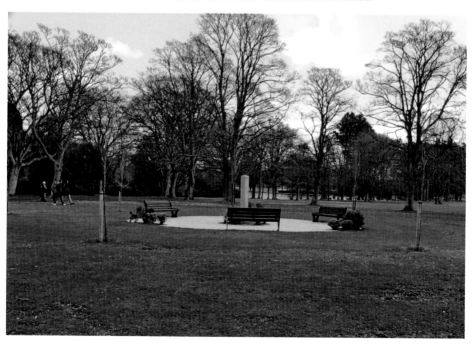

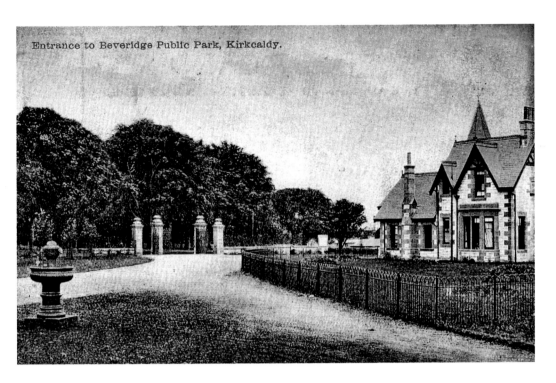

Entrance to Beveridge Public Park, Kirkcaldy.

Beveridge Park

Seen in both of the images is the main lodge, one of two built in the park. The basic layout of the park remains largely unchanged as shown in these images. I think the colourised postcard image wrongly shows the lodge as being white, I believe it was always its natural looking grey and red stone colour.

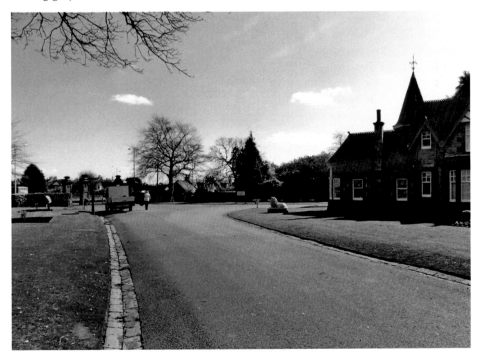

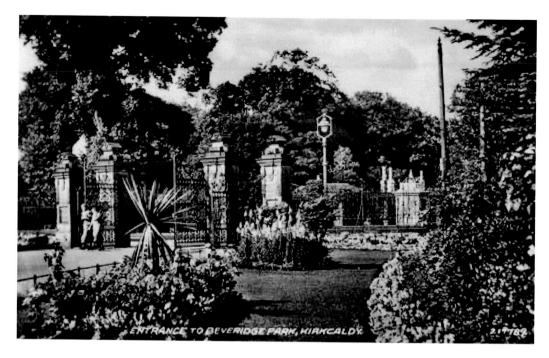

Beveridge Park

The old image shows some rather elaborate floral displays in front of the original main entrance gates and railings. They were removed to aid the war effort, along with four cannons, and were never replaced. Two lion statues remain at the lodge apparently guarding the entrance to the park. This area looks much plainer and is set out for ease of garden maintenance.

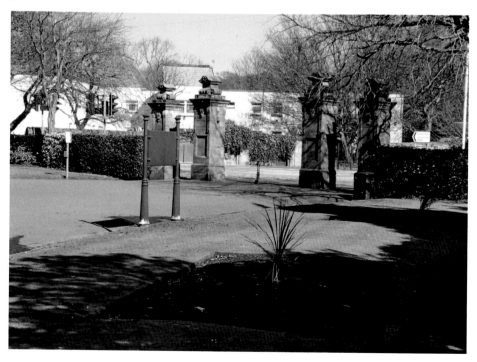

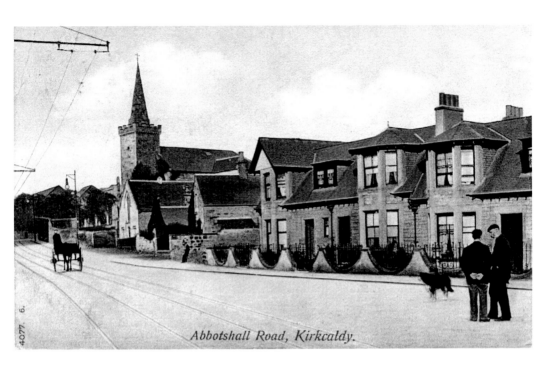

Abbotshall Road, Kirkcaldy.

Abbotshall Road

Surprisingly little has changed in this area except for the removal of the rails and overhead power lines. A few pieces of modern signage and safety railings seem to be the only changes to have taken place. This area near the park entrance was also a tramcar terminus on a short spur of line from Whytescauseway.

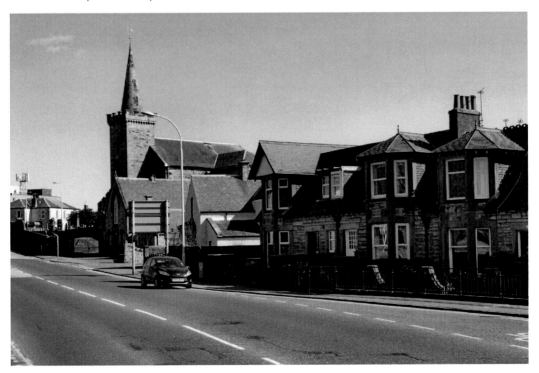

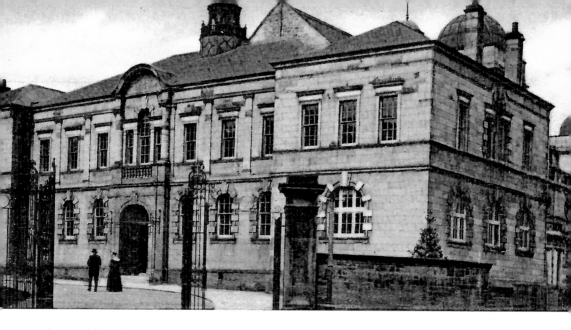

Adam Smith and Beveridge Halls
A fine close-up study of the exterior of the building which first opened its doors in 1889. Although primarily a theatre, it can also be used as a cinema as well as playing host to various societies, classes and workshops.

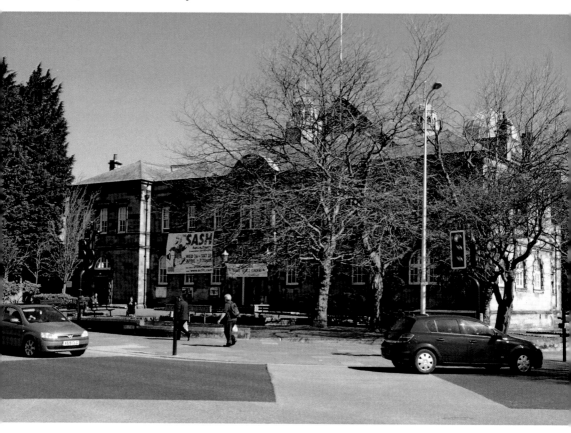

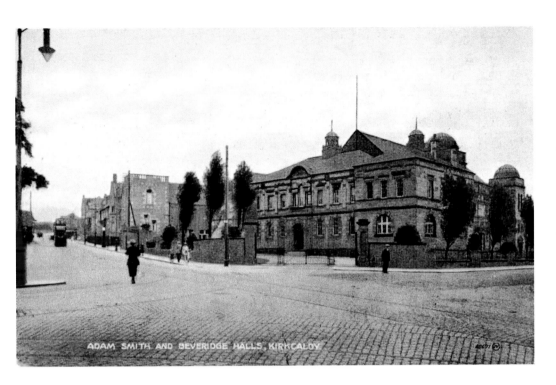

Adam Smith and Beveridge Halls

Here we see a more open view of the theatre, showing the surrounding area at the Bennochy Road junction. The tramline leading off to the left is the short spur to Abbotshall Road as previously mentioned. The road layout has retained its generous width at this busy junction.

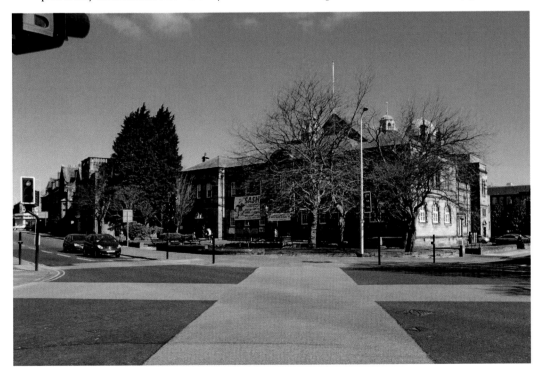

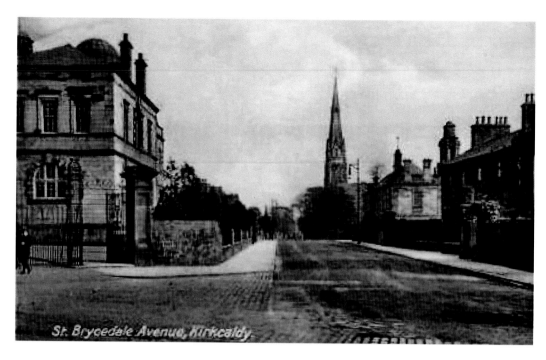

St Brycedale Avenue

Surprising little has changed in these comparative views with the exception of the obligatory modern road traffic lights. Behind the trees on the left of the modern image, you will find the St Brycedale Campus of the Adam Smith College.

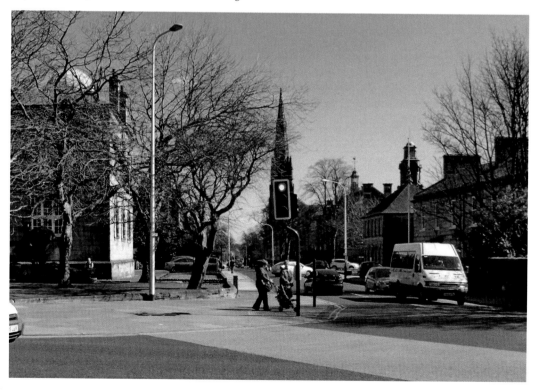

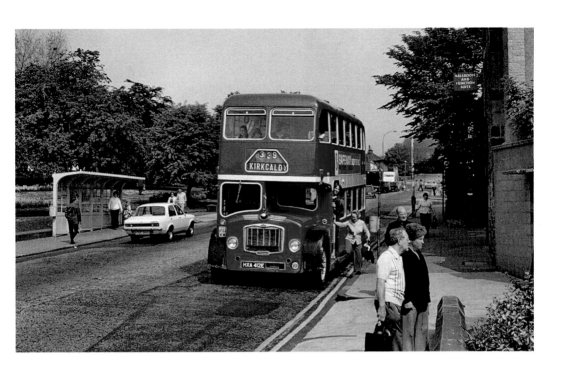

Bennochy Road
The bus stop outside the Adam Smith Theatre is still in the same place, but the one on the opposite side has now moved further up the road. Red and yellow flowers are seen to be prevalent still, in the memorial garden on the opposite side of the road.

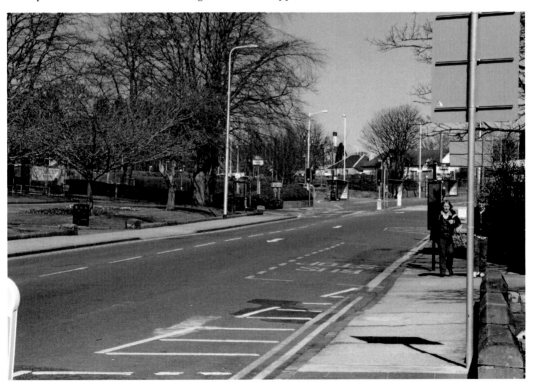

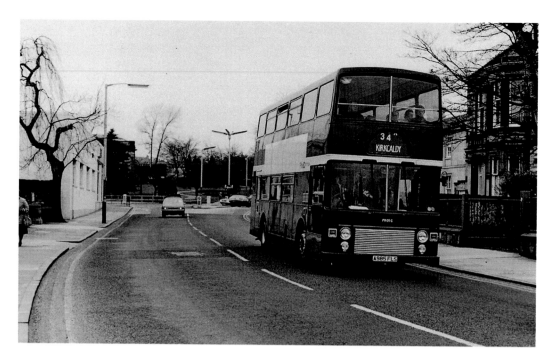

Wemyssfield

Further down from the junction at the Adam Smith Theatre is Wemyssfield. This road leads down to the town bus station and also passes by the Town House and a former main Post Office building. The only noticeable change between these images is the removal of the building on the left before the junction. If memory serves me right, it was a car showroom.

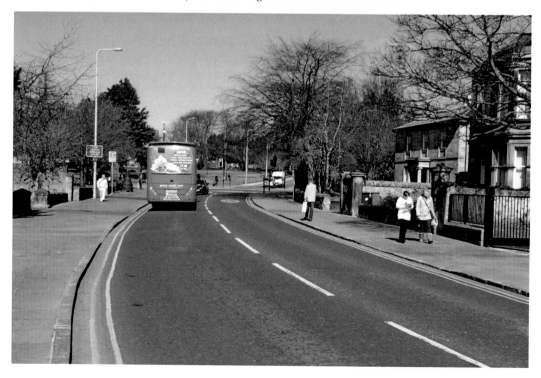

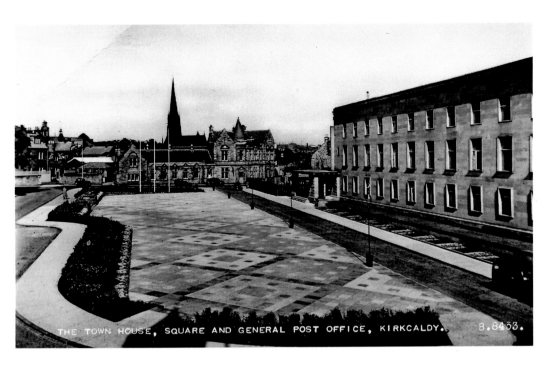

THE TOWN HOUSE, SQUARE AND GENERAL POST OFFICE, KIRKCALDY. B.8453.

Town House and Square

Construction on the new Town House started in 1937 after the decision was made to relocate from its previous premises on the High Street. The outbreak of war in 1939 saw construction work halted, and it was not until 1950 that work resumed, in stages, to complete the building. The old image shows the completion of stage one of the new Town House.

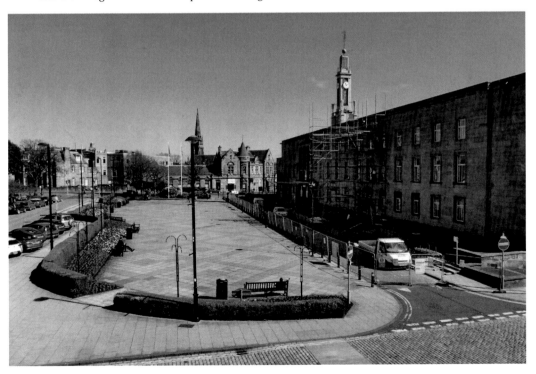

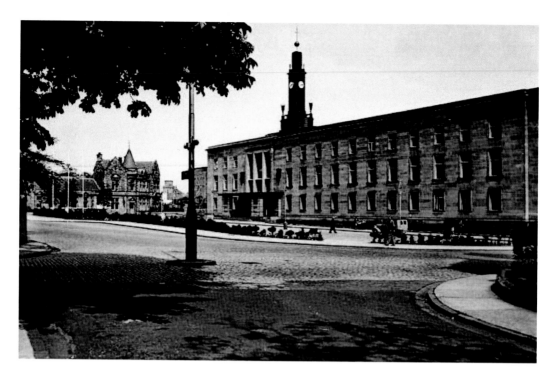

Town House and Square

The Town House has now been completed and the building itself has remained practically untouched over the last sixty years or so. The square, too, has remained largely as it did when built and remains a large open area with planted flower beds and shrubbery.

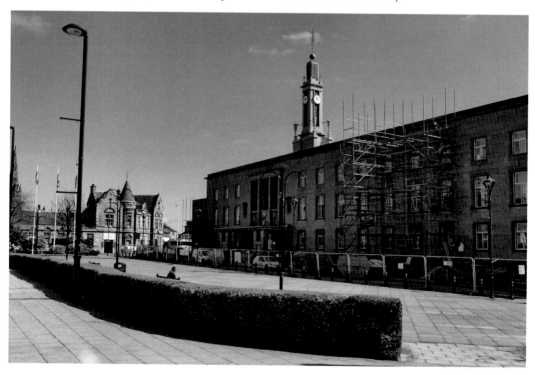

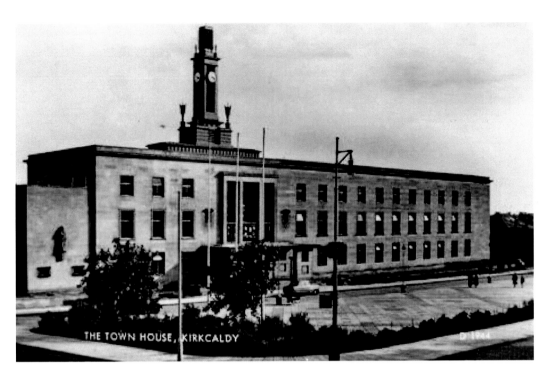

THE TOWN HOUSE, KIRKCALDY

Town House and Square

At present, the Town House is undergoing a £3 million refurbishment to allow the creation of a 'one-stop shop' for council services in the area. The square frequently plays host to popular 'Continental' and 'farmers' markets.

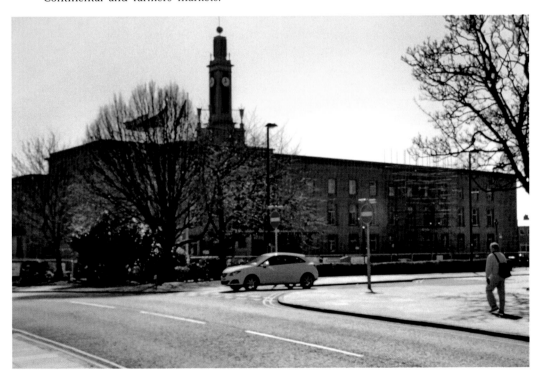

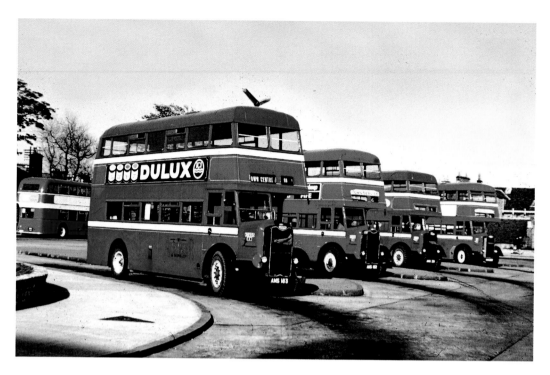

Bus Station

When Kirkcaldy was expanding in the 1950s, a new bus station was built to the north of the town centre to deal with the local town services. This remained the case until the 'Country' bus stance on the Esplanade closed in 1980 when all services operated from this newer location. It was last remodelled in 2007, but still retains its open and spacious look.

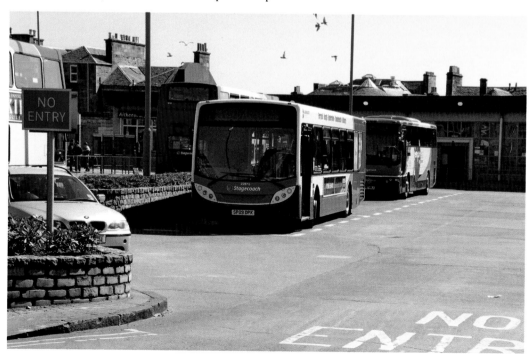

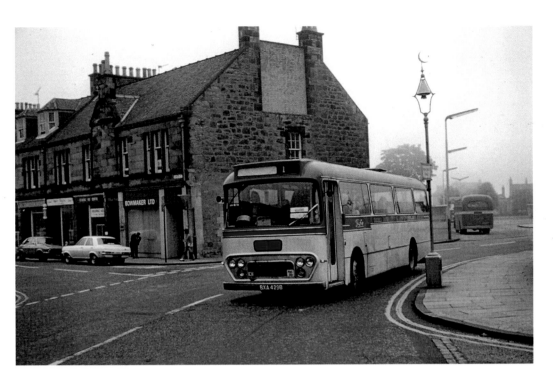

Wemyssfield

Not much in the way of change at Hunter Street road end as an AEC Reliance with Alexander's bodywork leaves the bus station on a local run to Gallatown in 1975. The building's gable end must have served another purpose in the past with the makeshift brickwork between the chimney stacks.

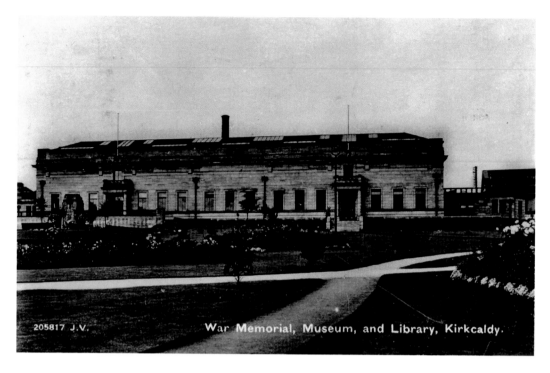

205817 J.V. War Memorial, Museum, and Library, Kirkcaldy.

War Memorial Museum and Library

Originally opened in 1925 as a museum and art gallery, there was an extension added in 1928 to house the library. The building is a part of the war memorial which was funded by linoleum manufacturer John Nairn, in memory of his son, and other townsfolk who gave their lives during the Great War.

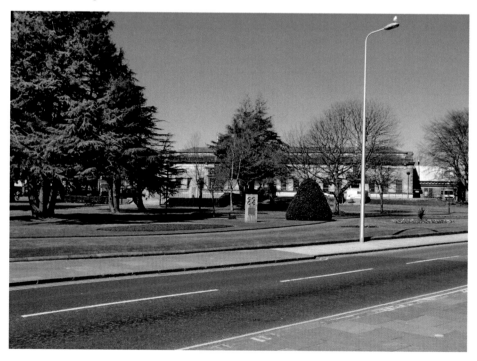

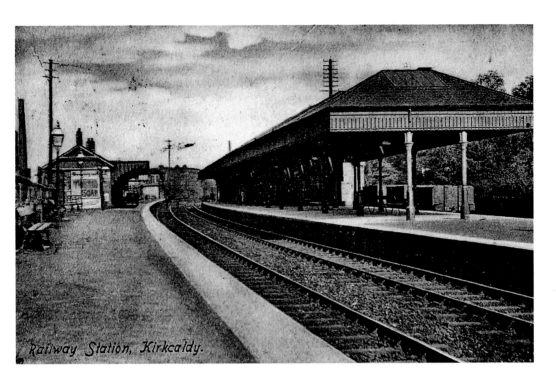

Railway Station, Kirkcaldy.

Railway Station

The platforms at the town's first railway station, built in 1847, were extensively covered by the overhead canopies as shown in the older image. There was a generous-sized goods yard just beyond the far side of the station. The third, and latest, station buildings can be clearly seen in the present image. It is a more open structure nowadays, but with little to show in platform coverage.

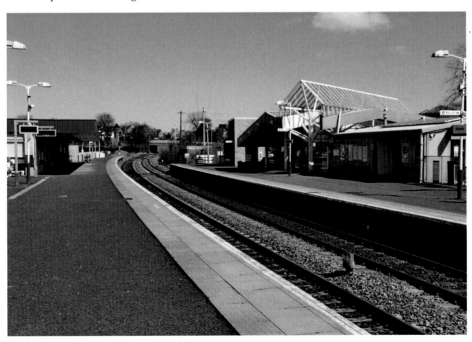

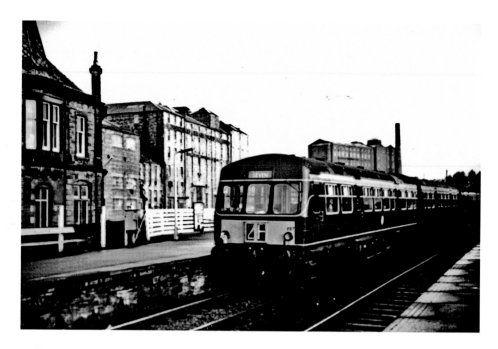

Railway Station

These images serve to illustrate how much the industry in Kirkcaldy has declined over the last half century or so. Gone are the large linoleum factories which surrounded the town's railway station, now replaced by large, open, green spaces. The Class 101 diesel multiple unit in the older image sits on the platform of the second station in 1967 before departing for the final leg of its journey to Leven.

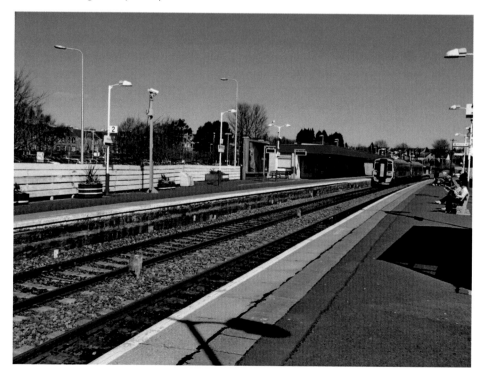

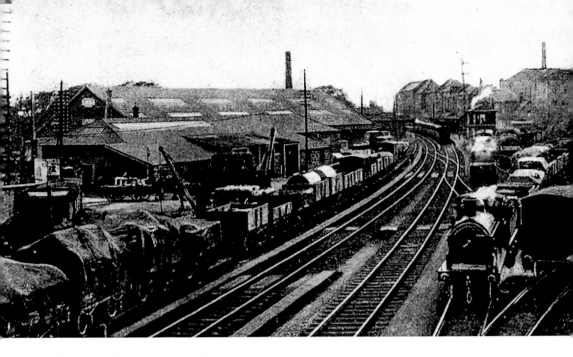

Railway Station from Bennochy Bridge

An excellent view here, of the Railway Station and goods yard as seen from Bennochy Bridge. The goods platform on the left has an abundance of wagons, some covered and others left open and still being loaded or unloaded. Other wagons can be seen on the right about to depart from the goods sidings at this excellent centrally located station. All that remains today is a 'passing loop' and the overgrown former goods platform on the left.

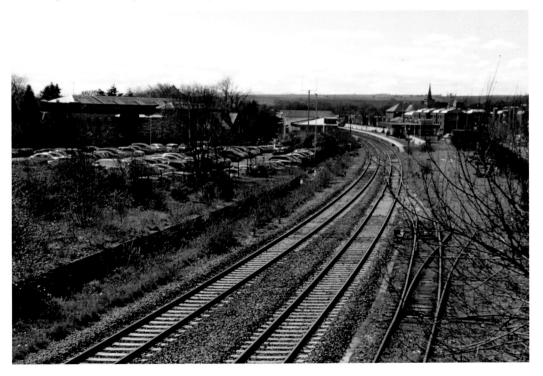

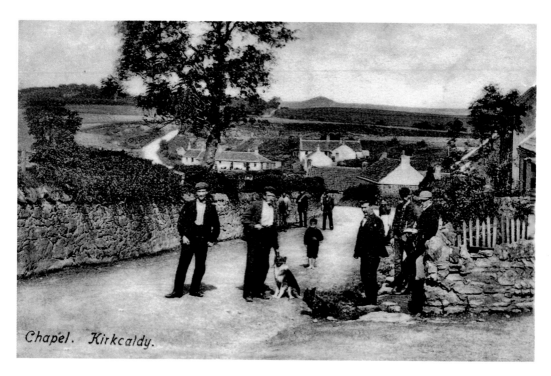

Chapel. Kirkcaldy.

Chapel Village
A view looking down from the Chapel Tavern, very much the focal point of the village not long after the start of last century. It was quite isolated and quiet back then, but is now a part of the vast housing schemes stretching outward between the town centre and the A92 road.

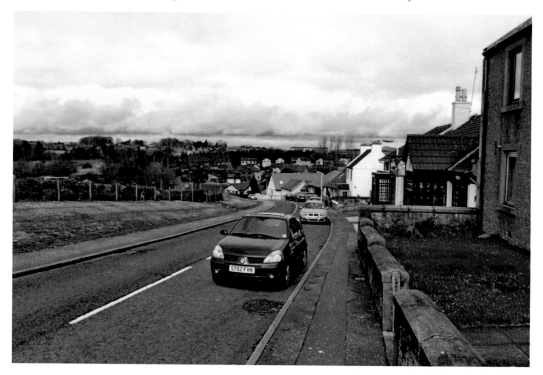

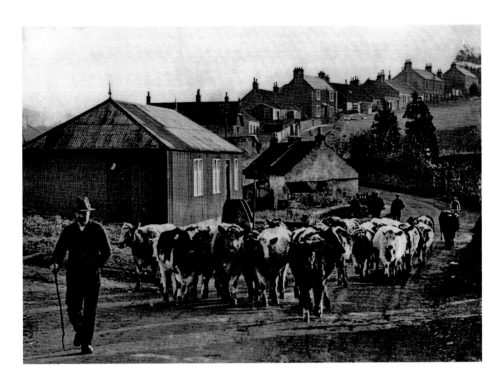

Chapel Village

We are now looking up towards the Tavern and we can instantly recognise the same couple of buildings in both images. The road layout, like other places, remains pretty much the same, although I can assure you that cows are no longer herded through the streets.

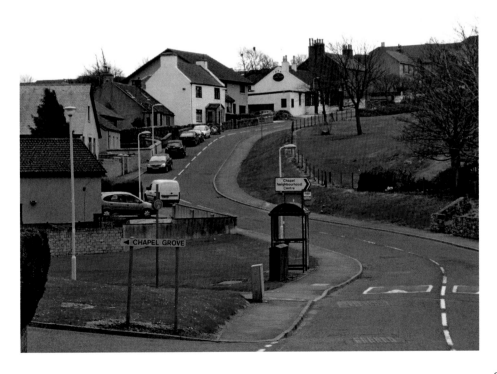

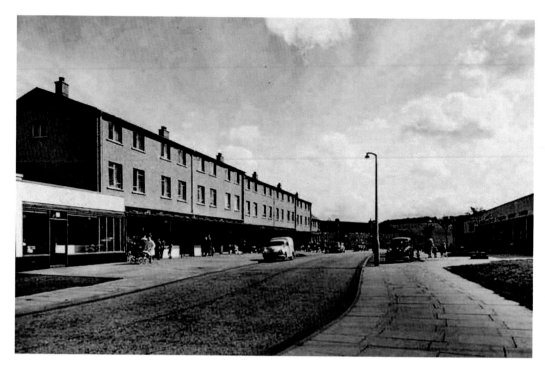

Templehall

Like Chapel, Templehall was another former farming area that was used for the expansion of Kirkcaldy in the 1930s. The local shopping area is shown here and has had a makeover in recent times. Like other similar areas throughout the country, the local shops have suffered in these 'belt-tightening times'.

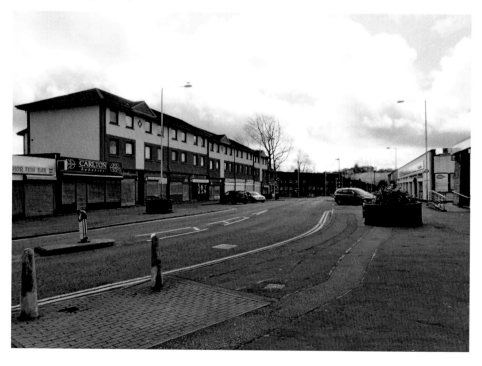

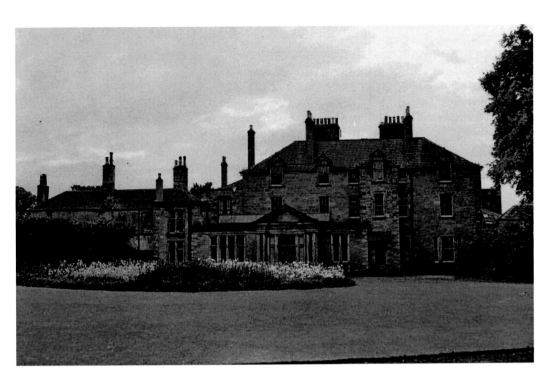

Dunnikier House
Built about 1790 by James Townsend Oswald, a local eighteenth-century politician, and described as 'a handsome mansion beautifully situated in a richly-wooded demesne'. A couple of minor extensions make the difference to the building, but the floral garden is a thing of the past as this area is now used as a car park.

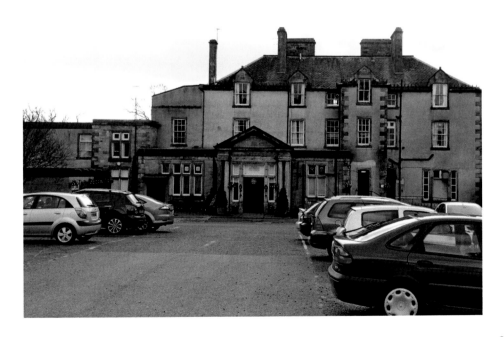

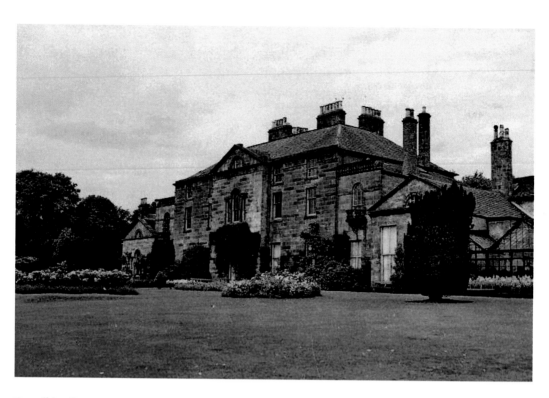

Dunnikier House

Little seems to have changed with the exception being, again, to the floral displays. The house is now used as a three-star hotel and sits adjacent to Dunnikier Golf Course.

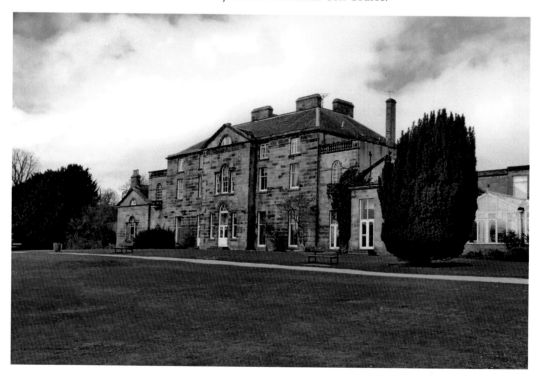

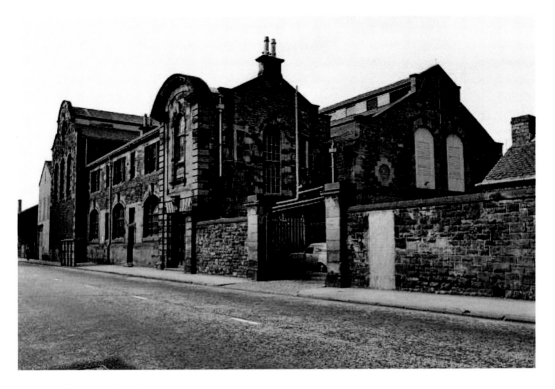

Early Power Station

Designed by local architect William Williamson, work began in 1899 on constructing this power station on the town's Victoria Road. Now seen in a much dilapidated state, with bushes and other plantation growing from its roof, this listed building is in serious need of restoration or maintenance. A used car dealership now occupies part of the grounds.

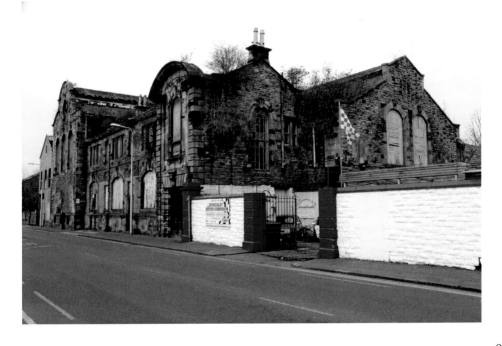

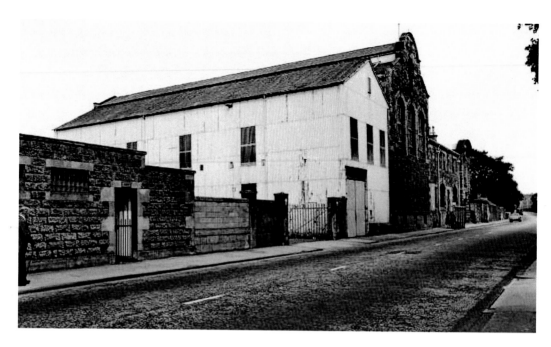

Early Power Station

The first power was generated from here during December 1902, a couple of months prior to the tram system opening, for which it was primarily built. It also supplied power for the town's street lighting and, if you could afford it, domestic lighting too. The later corrugated extension is also shown to be in a sorry-looking state.

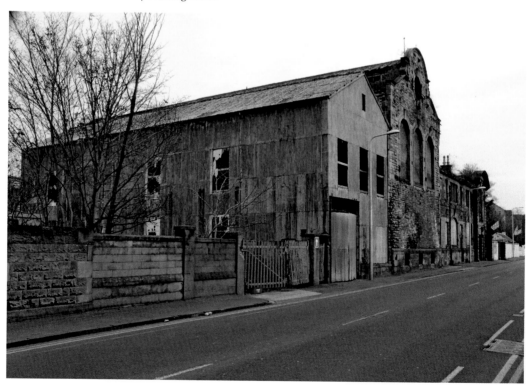

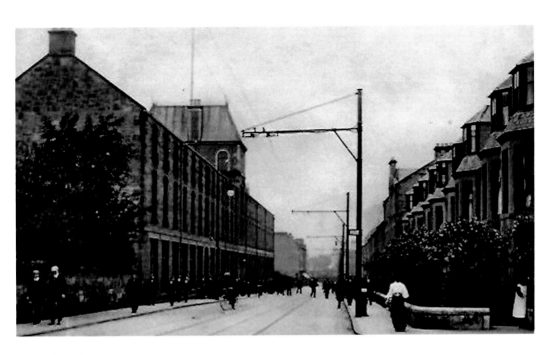

Victoria Road

Built in 1880, this was the former McIntosh Furniture Factory situated in Victoria Road. It was a rather successful venture with the premises having been in production for ninety years before moving to newer modern premises in 1970. It was knocked down and replaced by more modern buildings as seen on the left of the present-day image. The houses on the right-hand side remain largely unchanged.

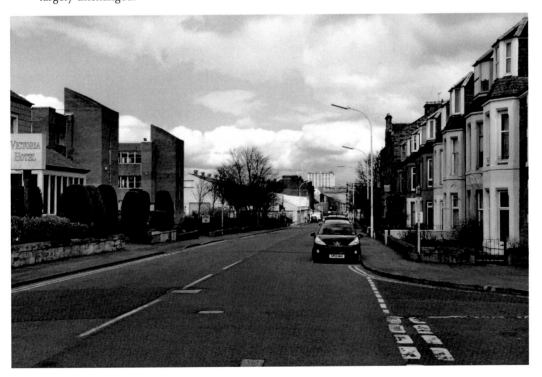

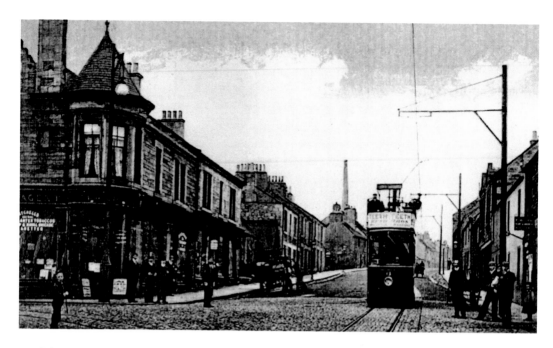

St Clair Street

The building on the left, and the Methodist Church behind it, are the only links between the two images taken in St Clair Street at the junction with the aptly named Junction Road and Loughborough Road. The radical changes to the houses in this area happened in the 1960s when a survey found almost half of the buildings had no kitchen, bathroom or indoor toilet facilities.

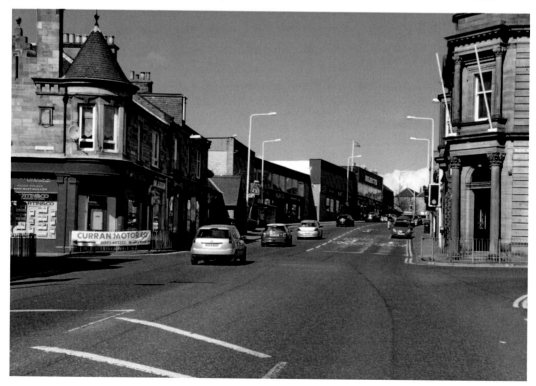

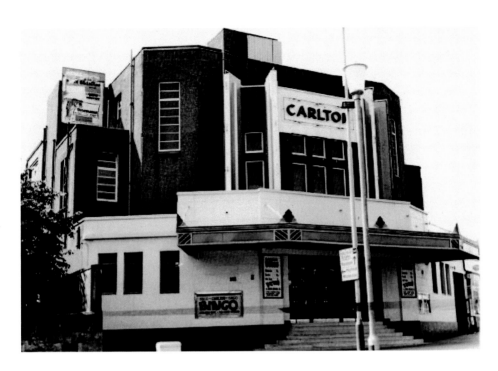

Carlton Bingo, Park Road

The Carlton, which stood on the junction of Park Road and St Clair Street, opened in 1937 as a picture house, but was later used as a bingo hall. It was one of three venues used by 'The Beatles' on a short Scottish tour in 1963 after the original venue, The Raith Ballroom, was deemed to be unsuitable by Brian Epstein, the band's manager. It was demolished after a fire in 1972. The wall on the left hand side is the only remaining link between these two photographs.

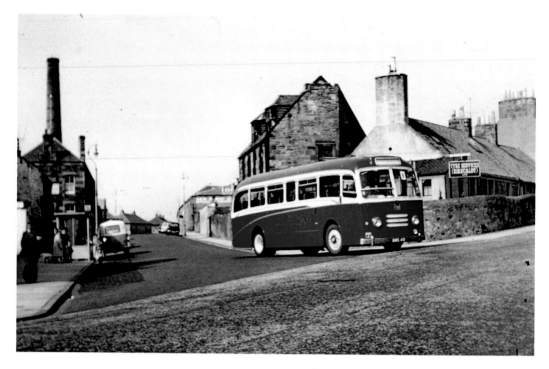

Park Road

Just to the right of the Carlton Bingo Hall, we see FGA9, an old Guy Arab single-deck bus belonging to Alexander (Fife), as it exits from Park Road. The building on the left is still standing almost fifty years later, albeit minus its roof and large chimney. The building on the right-hand side of the road almost midway up, is also still with us and is home to William Yule & Sons, a catering supply company.

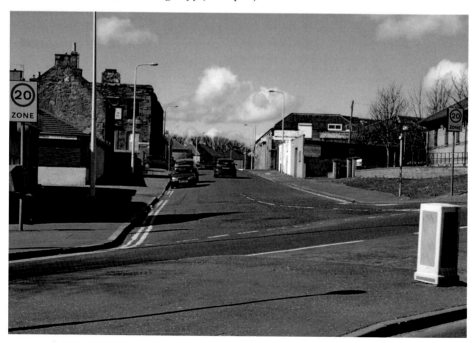

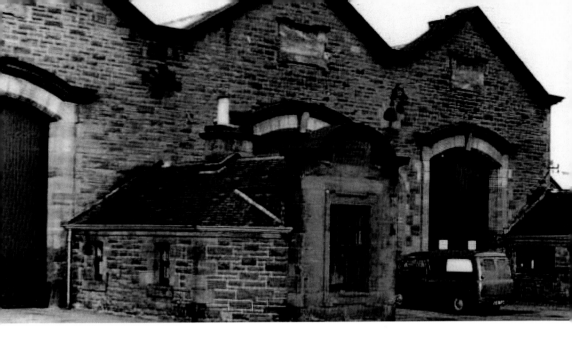

Gallatown Tram Depot
Built at the start of the twentieth century to house, and maintain, the tramcar fleet operated by Kirkcaldy Corporation. It was retained when the building was taken over by Walter Alexander's as a bus workshop, then latterly by local scrap metal merchant, Muir. The building was demolished in the 1980s with the former location being used by a local builder.

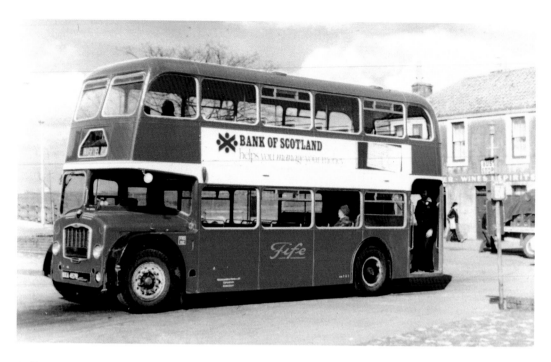

Gallatown Bus Terminus
The bus terminus, or turning area, situated in York Place, is still there but is not in use anymore.
The building in the background has changed uses from being a newsagent's and greengrocer's,
and has now become 'The Dining Room', a local restaurant.

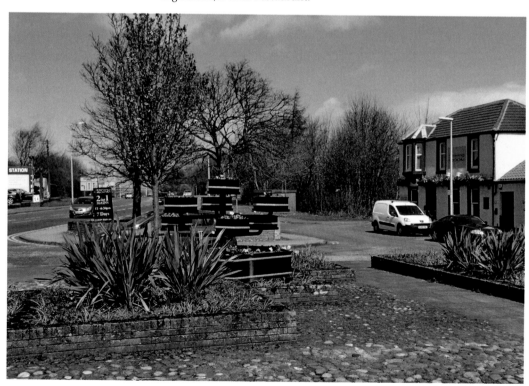

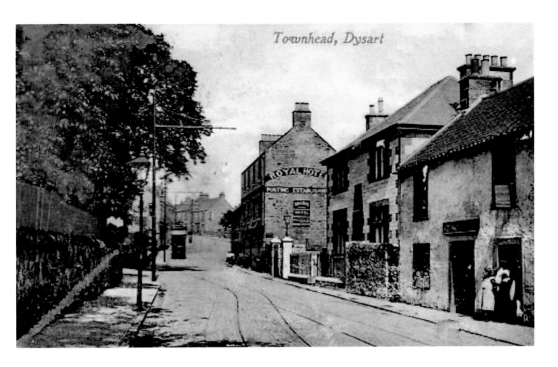

Townhead, Dysart

Dysart Townhead

A tramcar is seen heading up Normand Road towards the terminus adjacent to Fraser Place near the top of the hill. Little has changed when comparing the images with the exception of the new building on the righ of the present-day photograph, and the obligatory modern-day road signage and furniture.

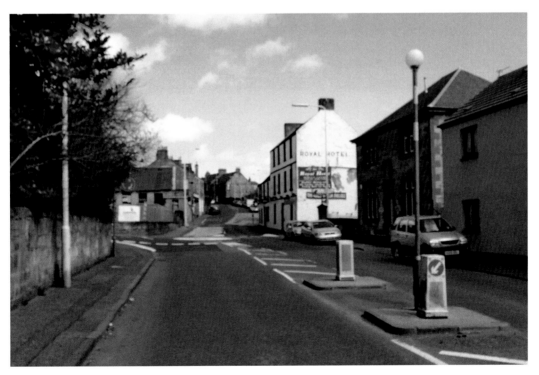

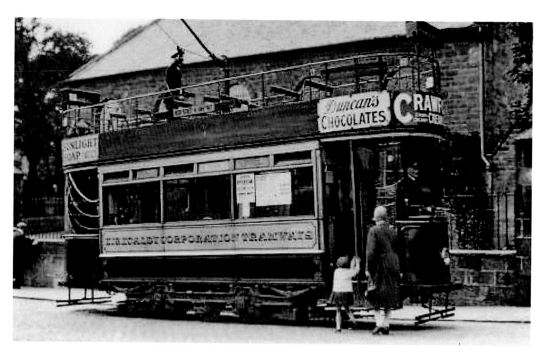

Dysart Tramcar

Behind the tramcar is Dysart Parish Church, later renamed as the Barony Church. It was built is 1802 and seated 1,600 people. A hall was added in 1932 and can be seen on the right of the present-day photograph. It was later used by the YMCA after the congregation merged with that of St Serf's and moved to the former St Serf's Church.

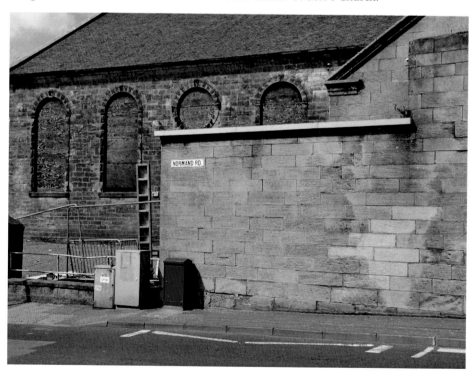

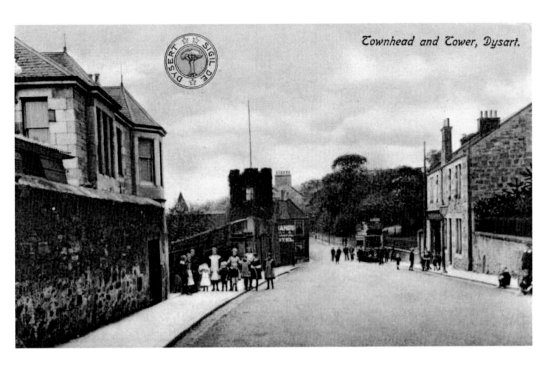

Dysart Townhead

We are now looking down Normand Road towards the Barony Church on the right, and we also see the unique square tower that once sat proud here. The only changes are to a couple of new buildings having been erected where the tower once stood.

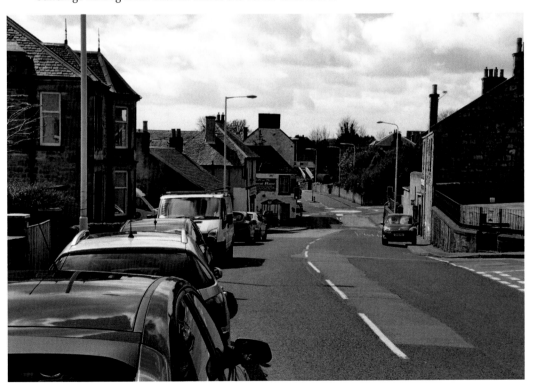

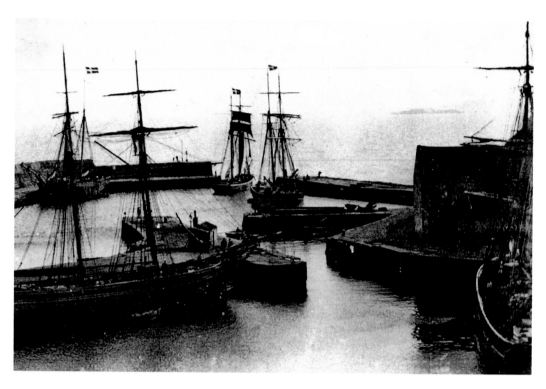

Dysart Harbour

The big ships are all gone now, to be replaced mainly by numerous smaller-sized pleasure craft. The building on the right in the old picture was apparently built by Dysart Town Council for the purpose of extracting oil from whale blubber. It never obtained its true purpose. It was latterly being used by Dysart Sailing Club but was destroyed in a fire early in 2012.

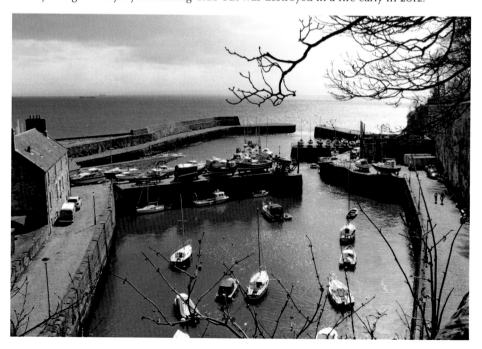

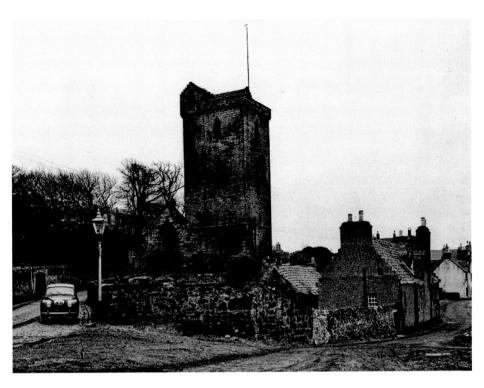

Dysart St Serf's Church

The area around St Serf's Church remains much the same when comparing the two images. There are modern improvements to the road at Pan Ha' Cul De Sac, and a new row of houses have been built in a style befitting the surrounding buildings.

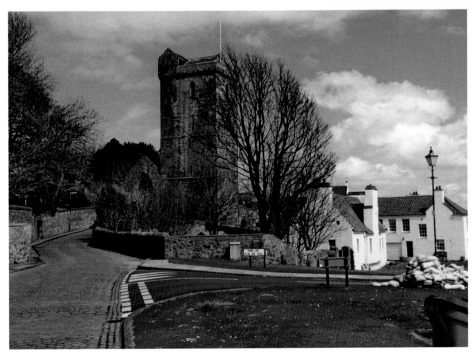

45

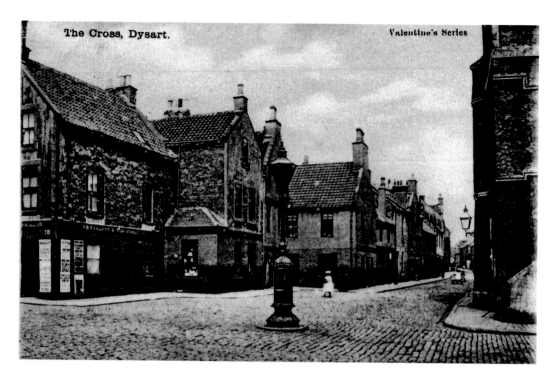

Dysart Cross

The first noticeable change is that the lamp has been removed from its original position in the middle of the road, and the buildings are now painted in a pleasant array of period colours. The first three buildings have also been heightened to some extent, either by adding another floor or raising a roof.

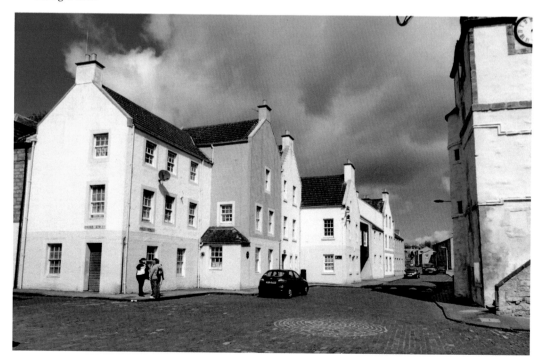

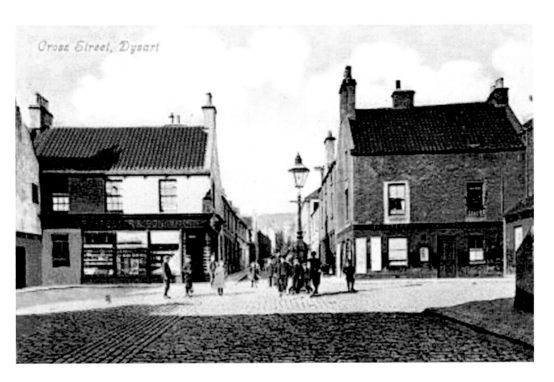

Cross Street, Dysart

Dysart, Cross Street

The scene here appears to look the same, and is very much recognisable, even without the ornate lamp. The buildings on either side of the street are no longer shops, and appear to be newer buildings. In the eighteenth and nineteenth centuries, this area was the location of annual fairs, but the tradition had all but died out by the start of the twentieth century.

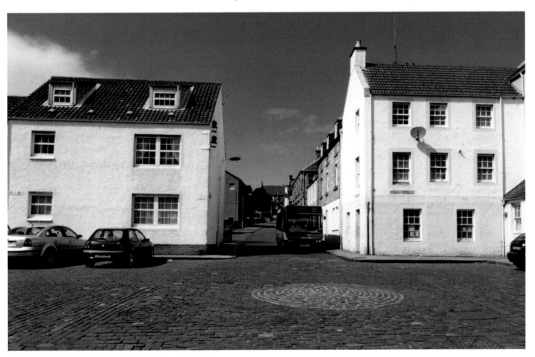

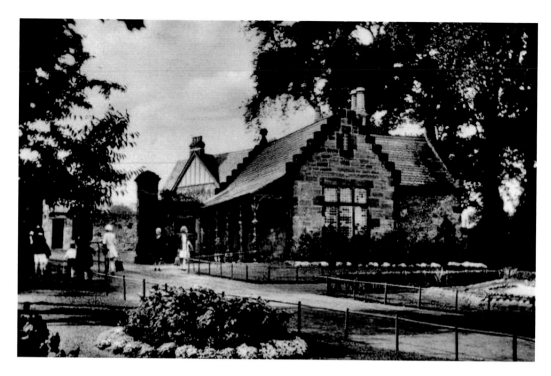

Ravenscraig Park Entrance

I had to look twice here to make sure I was in the right place, but the 'mock Tudor style' building outside the park made sure I was in the right location. I just don't know why people think a grassy area looks better than planted flower beds.

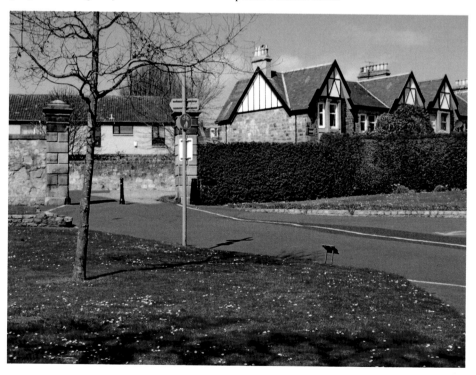

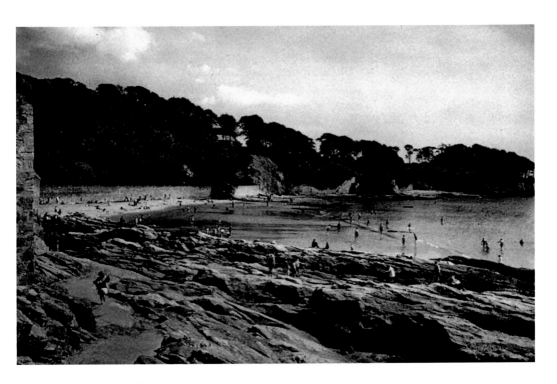

Ravenscraig Sands

I also found this one hard to believe it was the same location, until I read about the excessive ash tipping from the Francis Colliery, just up the road, having an adverse effect on the tides along this stretch of coast. The rocky area in the foreground is now unbelievably covered in a sand and shale or shingle combination. This effect also had more serious consequences further up the coast in West Wemyss with severe flooding caused by the shorefront filling in with mining waste.

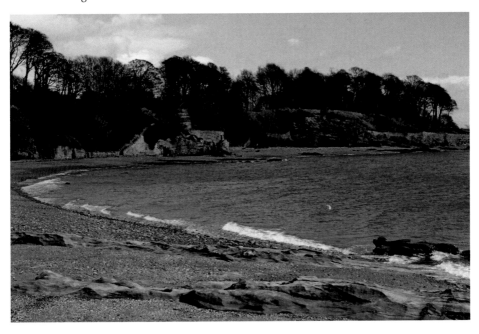

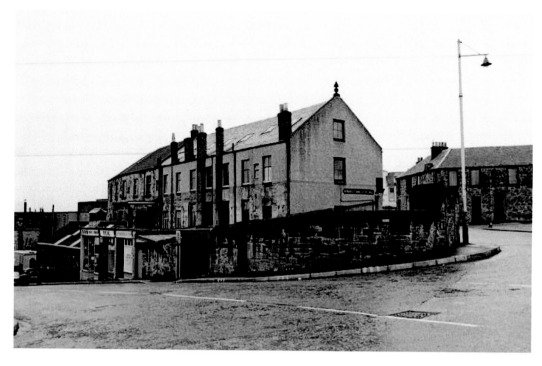

Dunnikier Road

Situated near the bottom end of Dunnikier Road, at the junction with Mitchell Street, this area has remained largely unchanged. The only changes immediately noticeable are the removal of a few chimneys on the rear of the shop units and flats in Mitchell Street. The houses on the right have also been 'freshened up'.

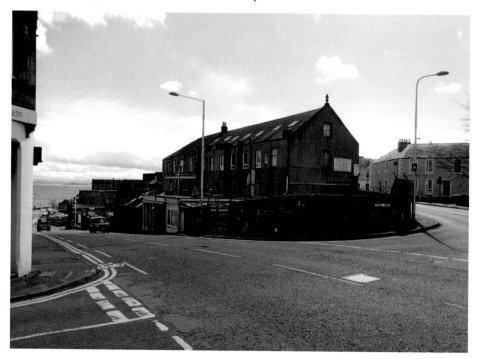

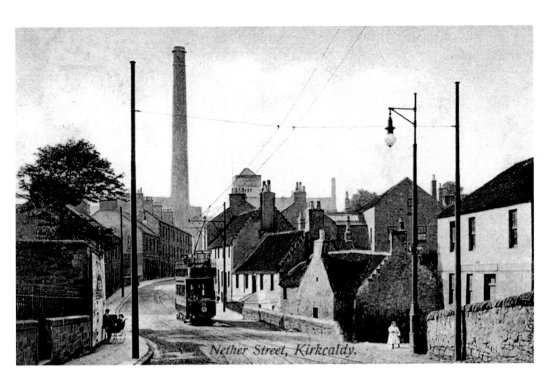

Nether Street, Kirkcaldy.

Nether Street

Well! What can you say? This whole area is totally unrecognisable from the postcard image taken almost 100 years previously. This is obviously due to the decline of the industries that once dominated in this area, not that it is necessarily a bad thing, especially in this instance.

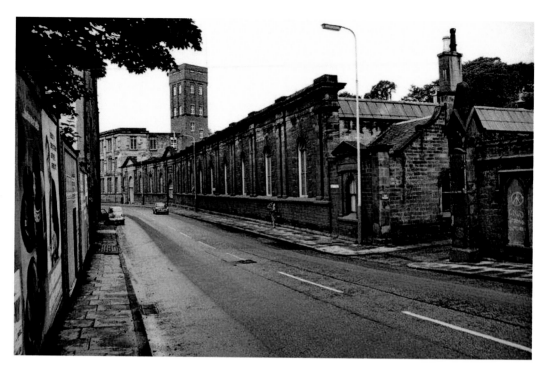

The Path

Once belonging to Nairn & Co., only the facade of this former linoleum factory remains. Behind the walls is a new complex which is partly used by the Adam Smith College. The advertising boards on the left have been removed which has opened the area up a bit more.

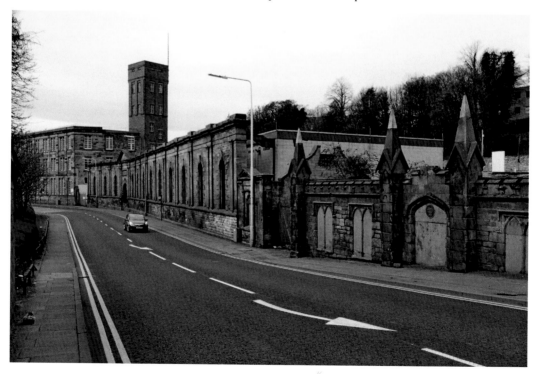

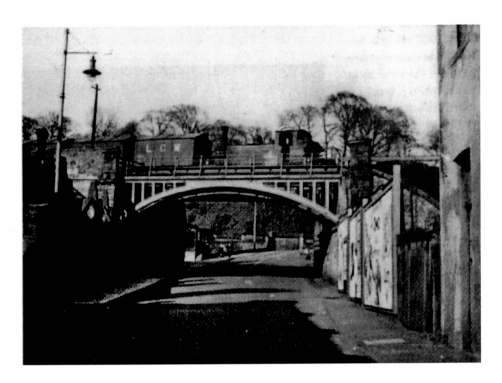

Harbour Branch Bridge

This bridge once carried a branch from the main line, down a steep 1 in 21 gradient to the harbour. This covered a distance at about 100 feet above sea level, going down to almost sea level within a distance of half a mile. The bridge has been removed, but there is still pipe work spanning the bridge abutments. Apparently the pipes are still used for the conveyance of coarse grain.

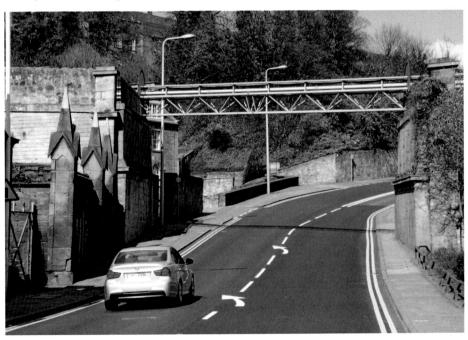

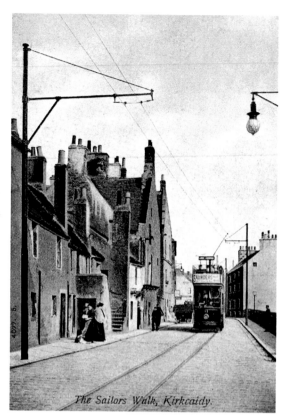

The Sailors Walk, Kirkcaldy.

Sailors Walk
Reputedly the oldest houses in Kirkcaldy, as they were originally separate dwellings. The right gable is also a former customs house, but they have also been known to have been former fisher tenement blocks. They are all that remains from the earlier view and are now under the ownership of the National Trust for Scotland.

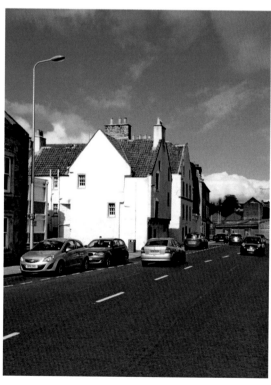

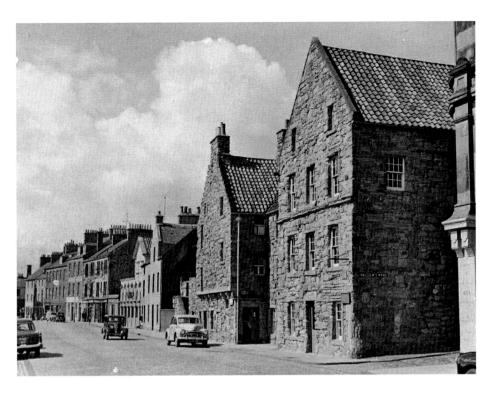

Sailors Walk

The Sailors Walk is again seen here, but looking from the east towards the town centre. Surprisingly little has changed between the images, apart from the harling and painting which has been done to the exterior of the building.

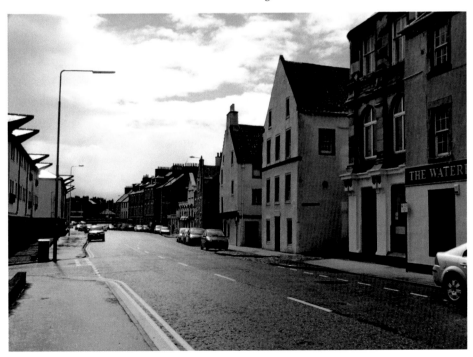

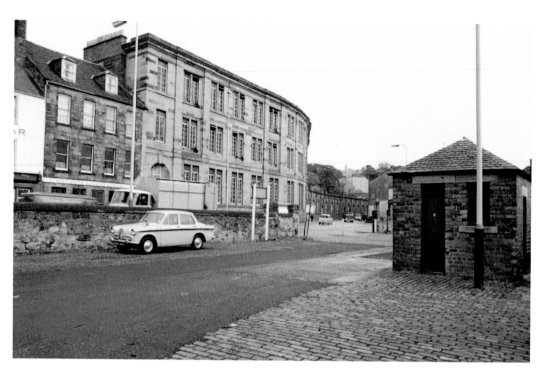

Harbour Area

The main difference to have taken place in the harbour area is in the location of the photographer. A new harbour housing development has now taken place on the dockside where once vast cargoes were loaded and unloaded.

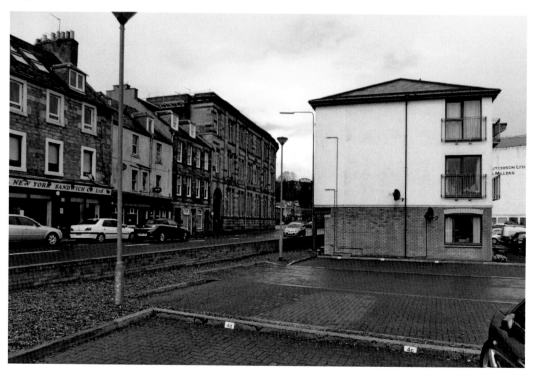

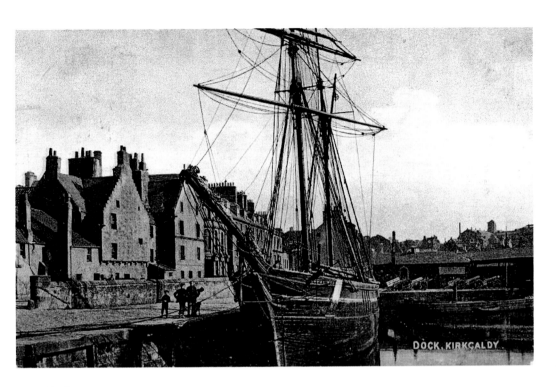

Harbour

What a difference 123 years make. Seeing sailing ships like this must have been a grand sight in their day. Not even a modest-sized ship will see the dockside at Kirkcaldy now. The modern dockside housing hides the Sailors Walk, which is still pretty much there.

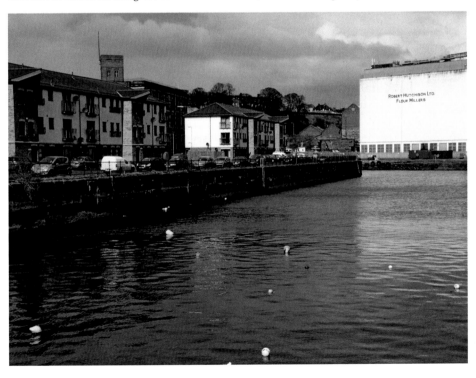

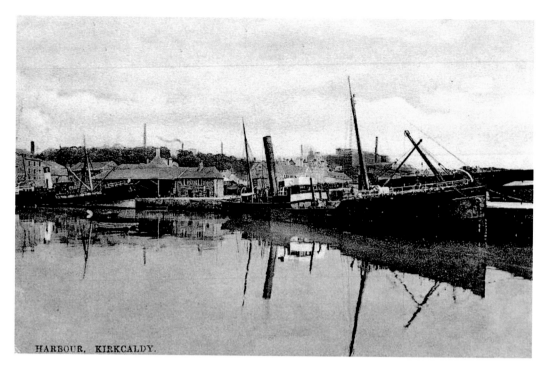

HARBOUR. KIRKCALDY.

Harbour

Steam power was pretty much the order of the day in this postcard image probably dating around 1910. These vessels would probably have been loaded with linoleum and other vinyl floor products, and despatched to most areas around the world. Prominent today in the background, are the silos of Hutchison's, the flour millers.

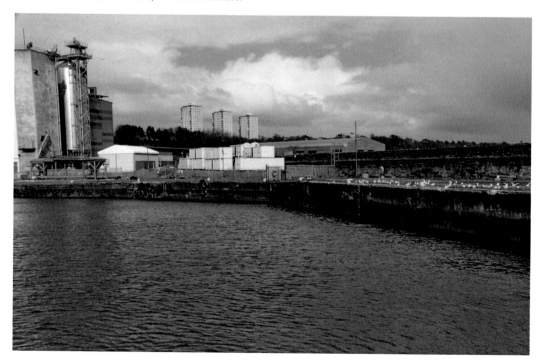

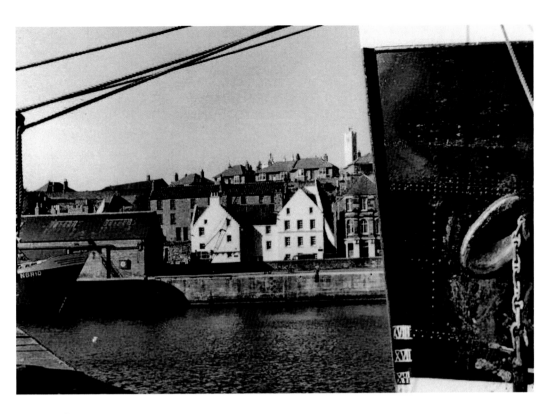

Harbour

Another scene, this time looking towards the dockside at the harbour, and how it has changed from its original use to that of a housing area. Surprisingly, though, the design of the new houses, or apartments, fits in rather well to the other surrounding buildings in the area.

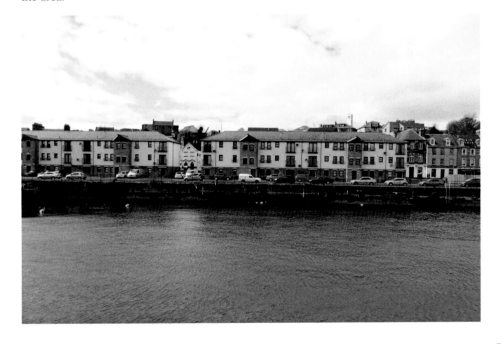

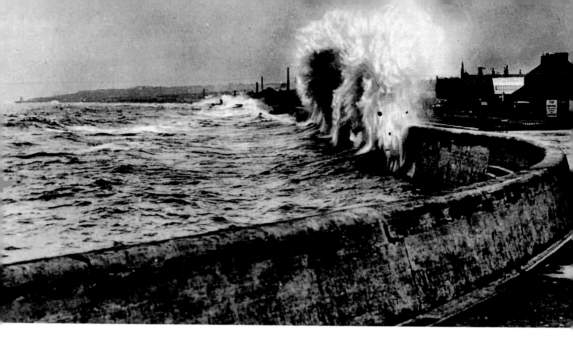

East Promenade

A typical scene of how the sea wall copes doing its job in defending the seafront from flooding. Unfortunately, it is not always enough, and the promenade has flooded on many occasions through the years. A plaque on the sea wall at this corner serves to remind visitors that it was the site of St James Church, which sat here from 1842 to 1970.

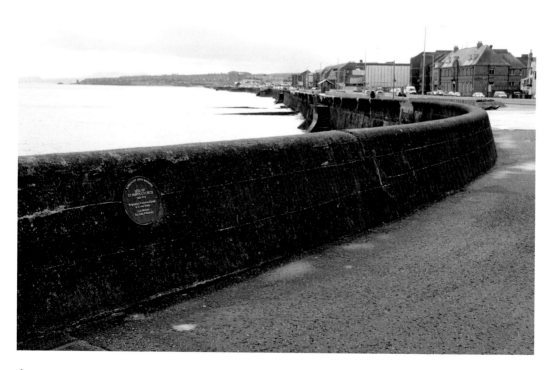

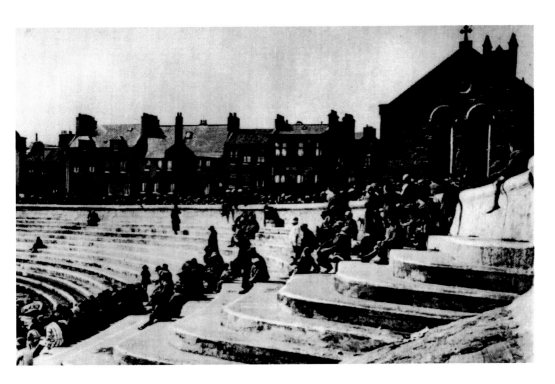

Sea Wall Steps

The steps, on the promenade side of the harbour, were once a popular meeting place for the town's folk. Sunny days were busy with young and old alike, wading in the water or just sitting in the cool sea air. The previously mentioned St James Church can be seen in the older photograph.

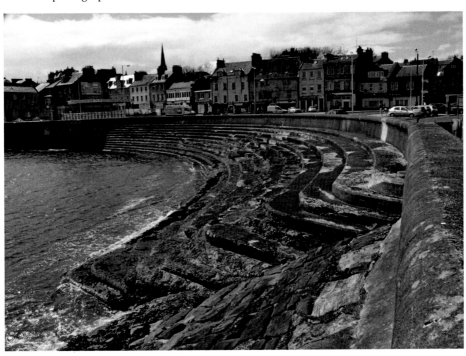

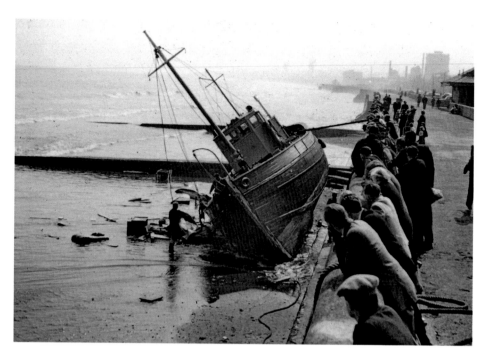

Boat in Trouble

High drama in 1959 when the boat belonging to Kirkcaldy Sea Cadets came out of the harbour too early and got itself grounded. It eventually ended up here against the sea wall. The cadets all managed to get off safely enough and the boat apparently ended up a complete wreck within a few days.

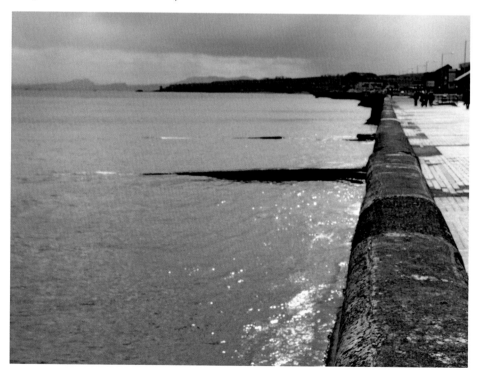

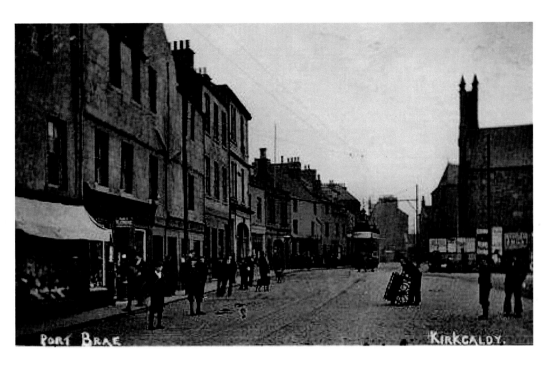

Port Brae

The location for the present-day photograph of Port Brae was determined by the spires of the old St James Church seen on the right of the old postcard image. Once I had determined that, two or three of the buildings on the left became so obvious. The building at the rear of the church is still there, but many shops on the left distance have been knocked down to make the area seem more open and greener.

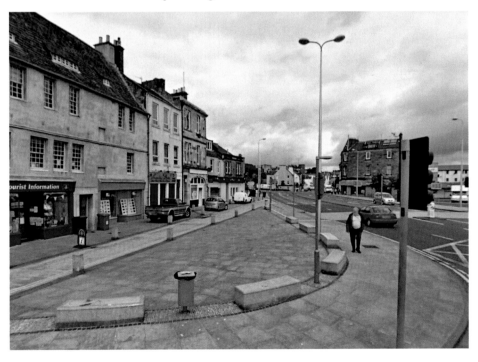

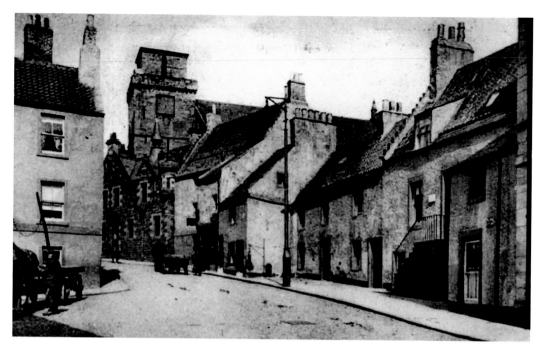

Kirk Wynd

Looking northward up Kirk Wynd, the white building we see is an eighteenth-century crow-stepped house once belonging to Matthew Anderson, a former church elder and meal dealer. Incorporated above the doorway is Matthew's coat-of-arms. This listed building is now in use as offices.

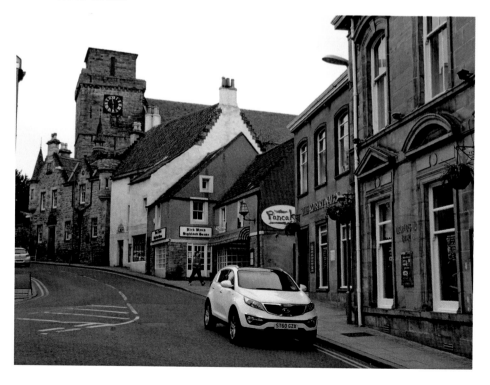

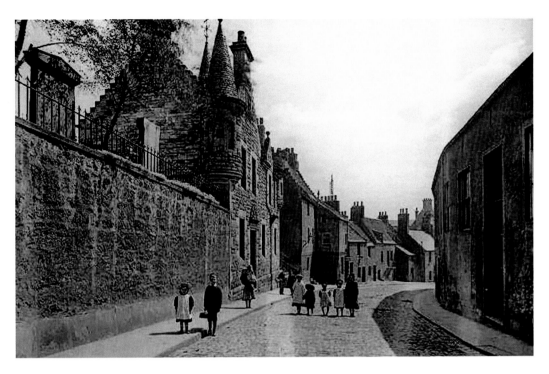

Hendry Hall

Situated next to the church on Kirk Wynd, we find this beautiful-looking Baronial-style building called Hendry Hall. The hall was constructed by a local linoleum manufacturer, Daniel Hendry, and dates from the 1890s. The upper floor was used as a Session House.

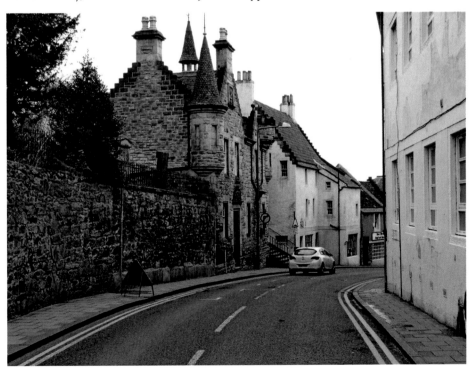

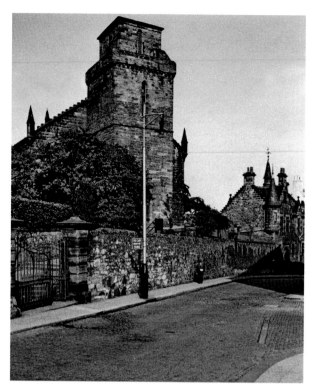

Top of Kirk Wynd

This is one area of Kirkcaldy town centre that looks like it has never advanced in time. Only the street lamp has been replaced and is suitably adorned with modern-day signage.

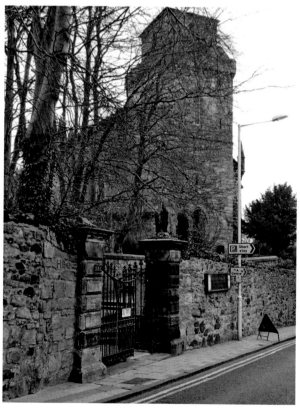

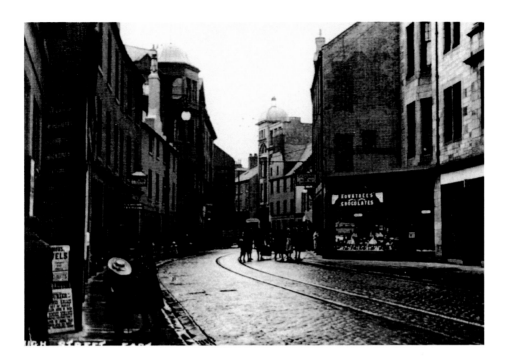

High Street East

The domed building on the left of the old postcard image started off as the King's Playhouse Theatre in 1904. Designed with a sliding roof to aid ventilation, it went through a series of changes before ending its days as the ABC Cinema, finally closing its doors for the last time in 2000. The building on the left has changed while those in the centre of the old image are no more.

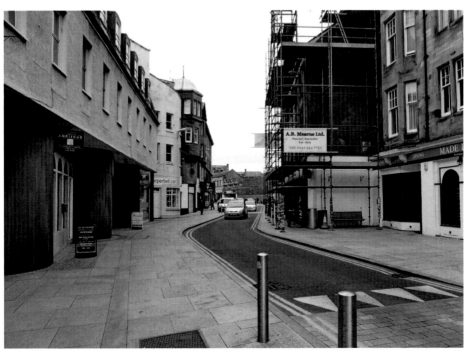

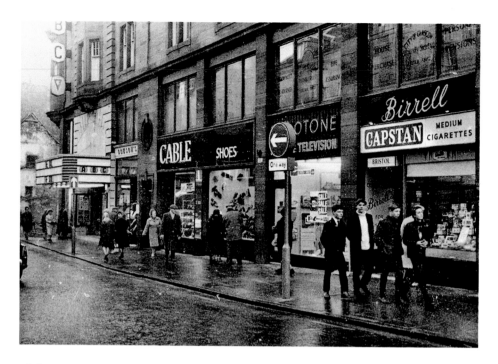

High Street East Cinema

A closer view of the building which encompassed the ABC Cinema is shown with the accompanying shop units. This is probably the late 1970s or early 1980s, going by the choice of shops on view. As previously mentioned, the cinema closed in 2000 and was Kirkcaldy's last, in a long line, of cinemas. Not much other in the way of change apart from the additional parking bays.

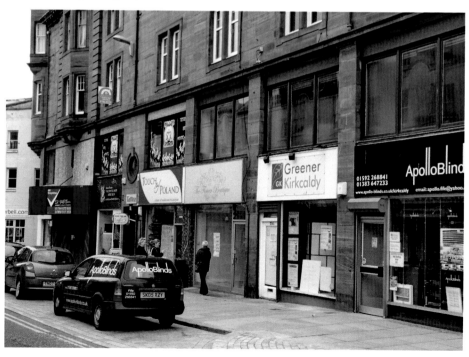

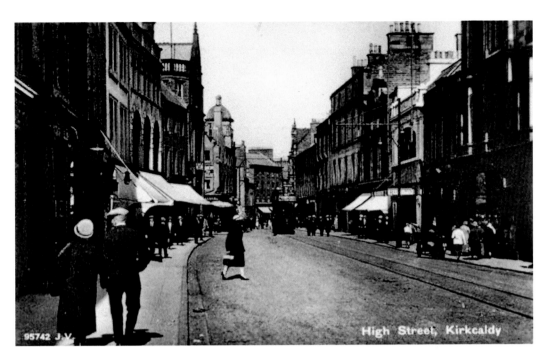

High Street, Kirkcaldy

95742 J.V.

High Street with Tram

The building in the centre of both images is the link between these two images, again showing the east end of the High Street. Many of the buildings on both sides have been replaced or altered, and I believe the modern photograph makes this area look too compact and claustrophobic.

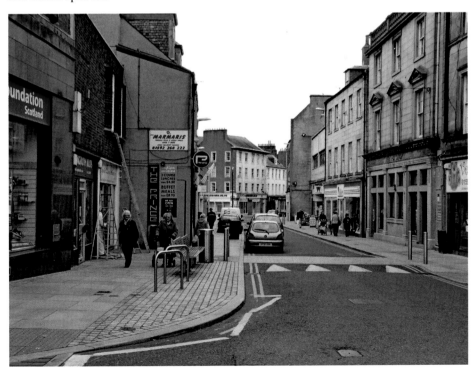

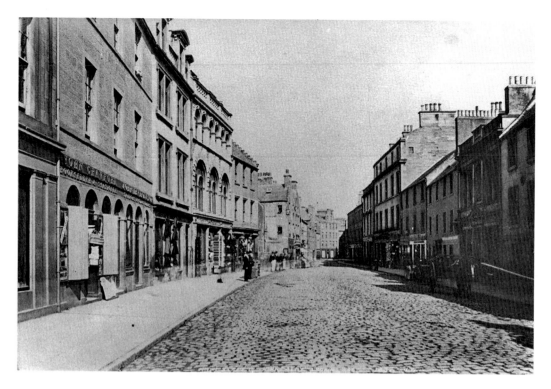

High Street Middle

Rather surprisingly, many of the buildings in the old image are shown to be still there today. This is another view of the east end taken once again from further back. This must have been around the turn of the last century as there are no motor vehicles or tram lines in place.

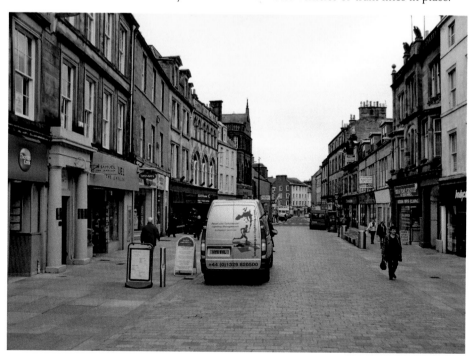

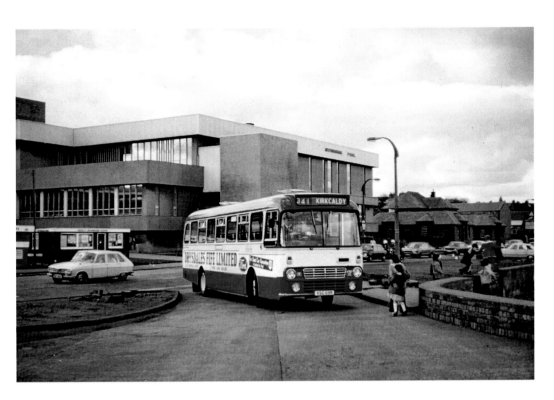

Esplanade Bus Stance

The entrance to the former Esplanade Bus Stance is shown here to illustrate the limited room the buses had to manoeuvre in this area. The bus is a Leyland Leopard and is seen in April 1979, about a year before services stopped using this stance. The area is now just an extension to the walkway along the seafront. The swimming pool was built in the 1970s and is due to be replaced later this year.

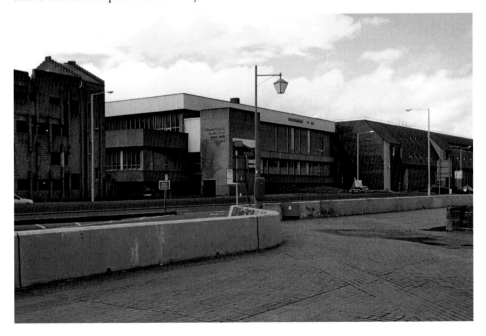

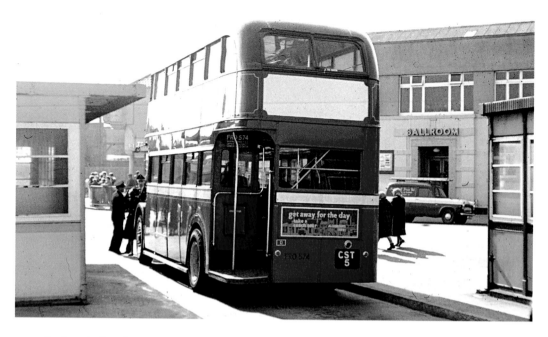

Esplanade Bus Stance

This is a view looking towards the seafront properties from the rear of the bus stances. As well as showing a typical bus stance, it also shows a part of the Burma Ballroom across the road. The Burma will be well known to many of the older town folk, but will be just as well known to the middle-aged ones as Jackie-O's nightclub.

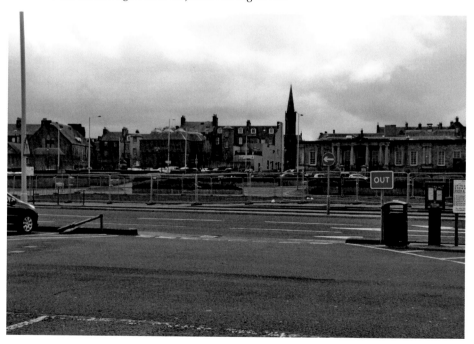

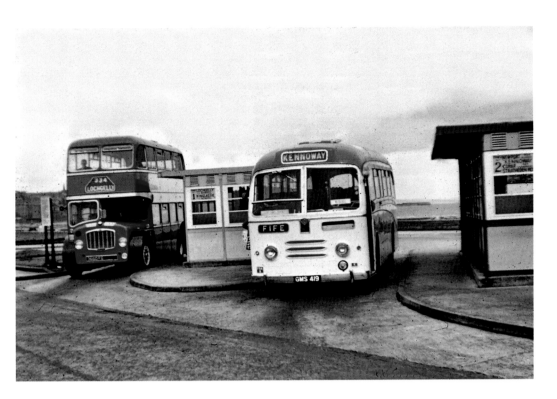

Esplanade Bus Stance

The third and final view of the former country bus stance on the Esplanade shows the stances and their exposed position on the seafront. The stances could be a vulnerable place to be when the winds got up. As can be seen, the whole former bus stance area has been utilised as a car park, and like the former bus stance, it can be very open to the elements when the seas are rough.

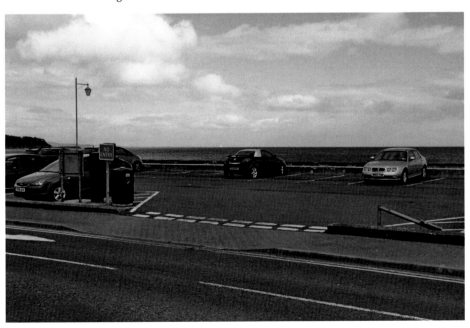

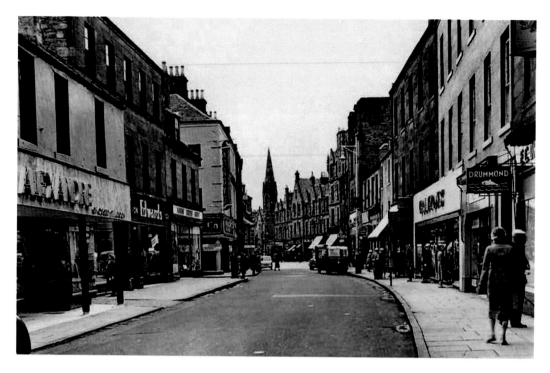

High Street Middle

When comparing these images, the most noticeable thing is the pedestrianised High Street, although going by the number of cars on show, one wonders if it is truly so. You may still have to dodge a few cars coming down the street. The left-hand side of this area of the High Street shows great change to the buildings with more modern shop units and a shopping centre, The Mercat, in this area.

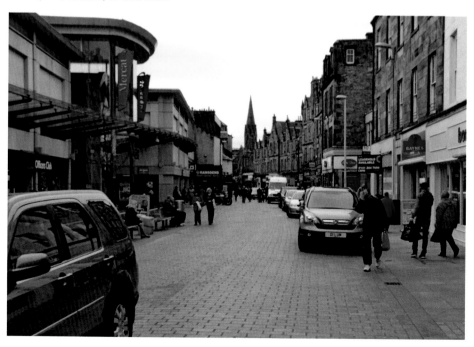

151–153 High Street
This building was designed and constructed about 1905 by local architect William Williamson. It was formerly used by the Royal Bank of Scotland and is now used by 'Savers', a health and beauty shop. As can be seen, there were alterations carried out to the ground level frontage in 1985.

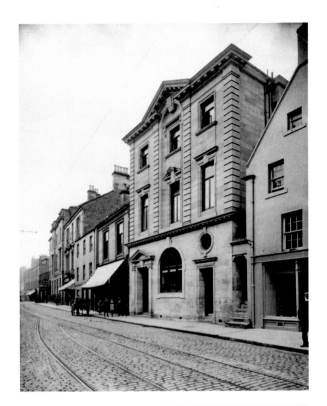

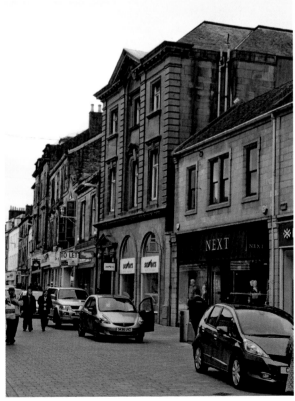

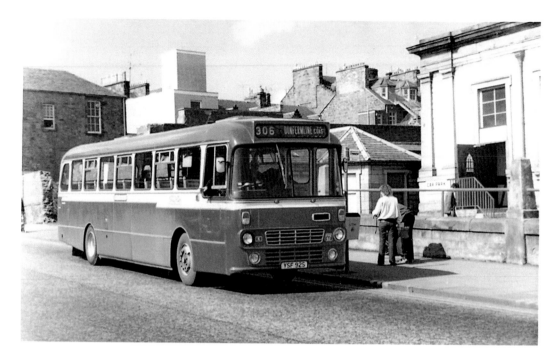

Charlotte Street

Not much has changed here with the exception being the removal of the small building at the rear of the former Philp School. This area has been enhanced by the surrounding shrubs and trees. The former school is now a nightlife social venue called 'Society', previously 'Caesars'.

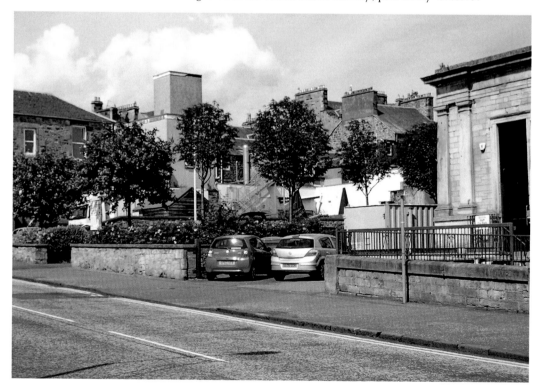

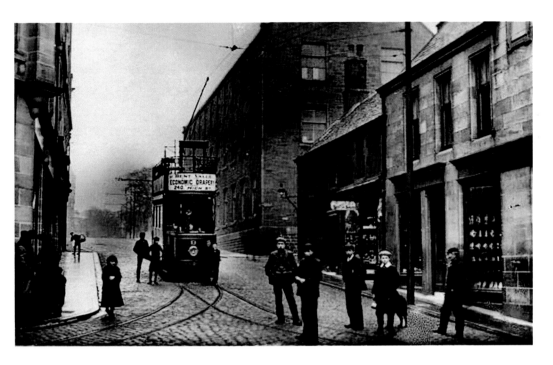

Whytescauseway

At one time known as Whyte's Causeway and named after Robert Whyte, the town's first elected provost in 1657. This was the tramline junction for either the High Street on the right, or to Linktown on the left. The large building on the right was Heggies Linen Mill, while the buildings on the right were replaced by the Burtons building in 1937.

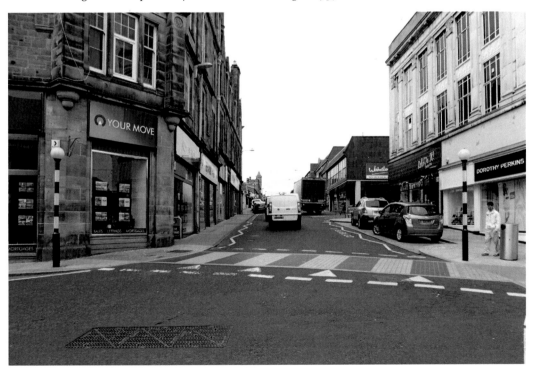

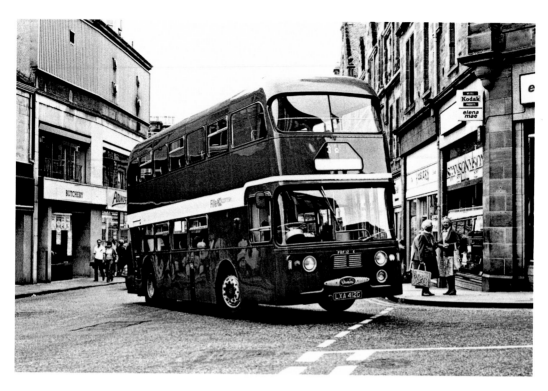

High Street, Whytescauseway

This is the junction at the bottom of Whytescauseway looking towards the west end of the High Street. Not a lot has changed here between the images. The buses still turn up Whytescauseway here en route to the bus station, while the road itself has been changed to a one-way system.

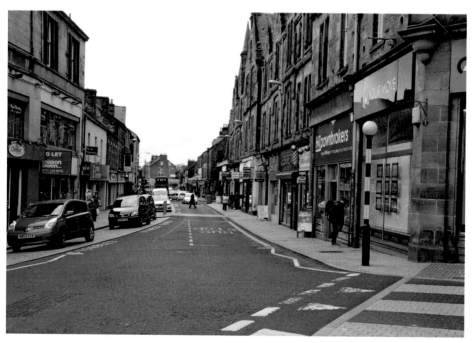

High Street, Whytehouse Avenue
These images are taken further back west and looking eastward, in particular towards the road on the left which is Whytehouse Avenue. Looking to the centre of the older image, we see the building owned by J. McBean which was later replaced by the Burtons building. Both corners at the bottom of Whytehouse Avenue have changed radically with the erection of newer shop units including Graham's china shop, the only single-storey shop built on the High Street.

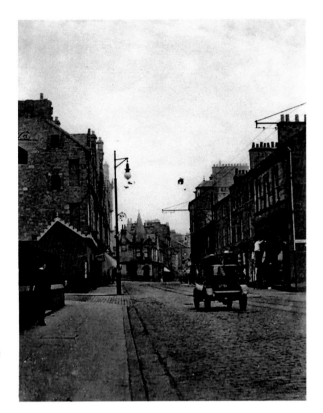

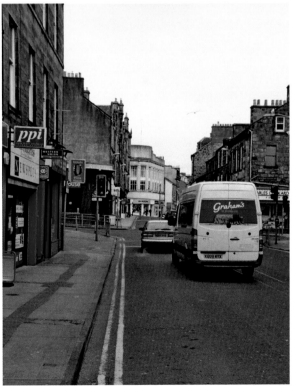

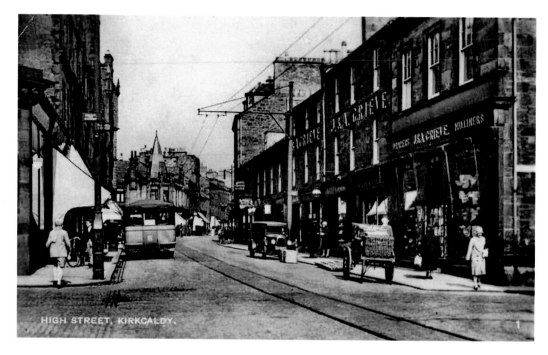

High Street, Early Bus

These images are taken from the same place but show a wider view of the shops in the area. The older postcard image probably dates from the early 1930s going by the early single-deck bus on show. The premises on the right belonged to J. & A. Grieve, Milliners, but today is the shoe shop of Charles Clinkard.

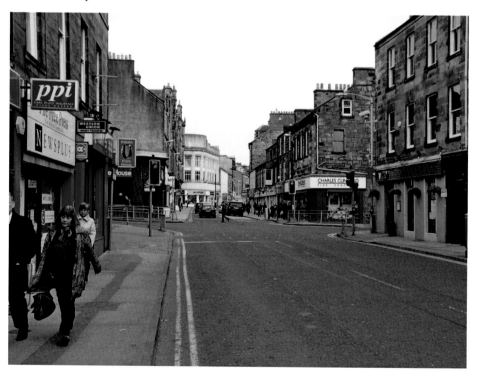

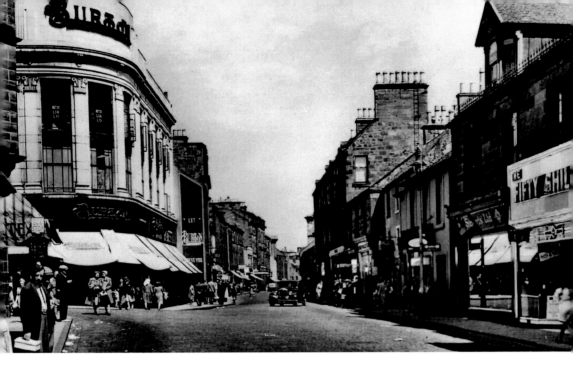

High Street, Burtons

An excellent early view showing the Burtons building as it looked, probably in the 1950s. It must have been a scorcher going by the number of sun awnings extended down the street. Two or three of the buildings adjacent to Burtons have been replaced by more modern structures while the High Street is now a pedestrianised area.

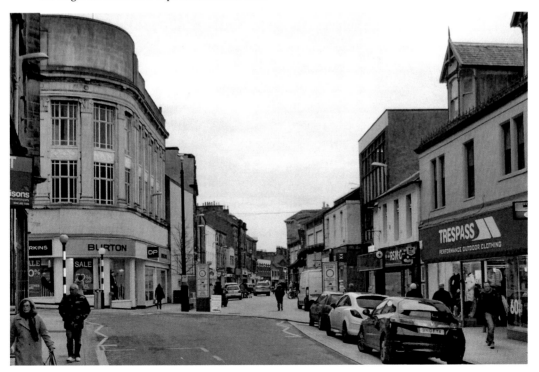

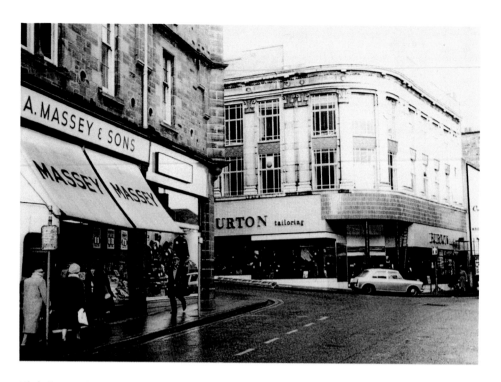

High Street, Burtons

The Burtons building is once again the focus of the photographs, but now we see how it looked around the early 1970s. Built in 1937 in the Art Deco style, the building is still owned by Burtons and has stood up well to the passage of time retaining many of its original features.

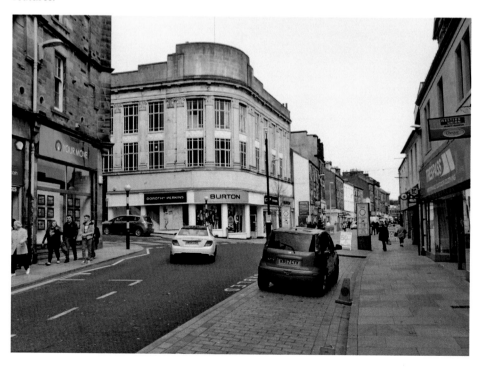

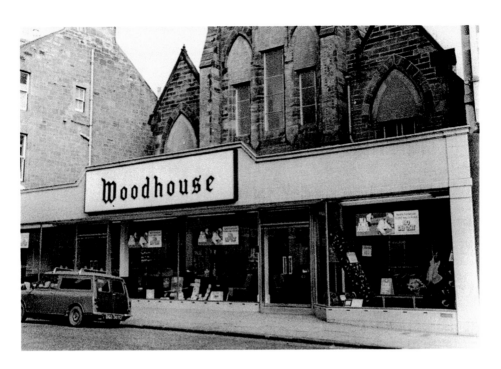

Abbotsrood Church

This church was built at the western end of Kirkcaldy High Street in 1875, as a replacement building for Abbotshall Free Church on Links Street and was originally known as Abbotshall Free Church until 1929, when it became Abbotsrood Church. The church closed in 1949 and the congregation moved to a new building at Hayfield. At some point after this the steeple was removed and the building was converted to commercial use. It now houses O'Connell's bar and diner and has a modern shop frontage.

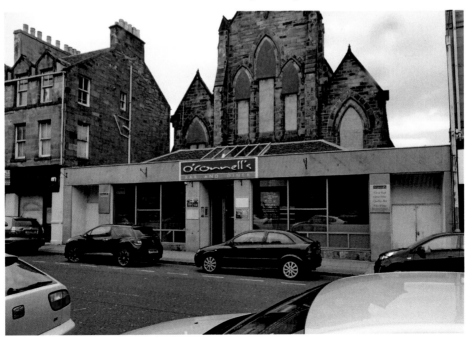

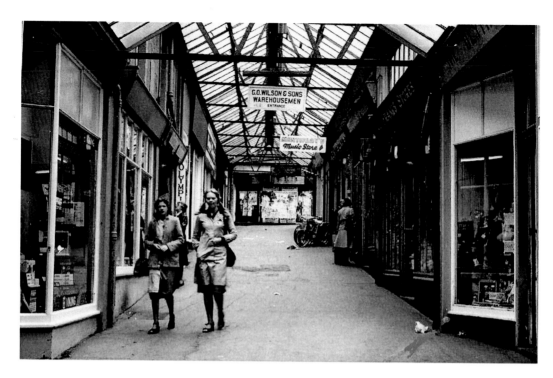

Olympia Shopping Arcade

Situated at the west end of the High Street, this small shopping arcade was originally part of a three-storey linen factory. The arcade was created when the original factory relocated to a 'more conventional' weaving shed in 1898. As can be seen here, the arcade has suffered seriously from neglect, and regeneration attempts appear to keep on stalling.

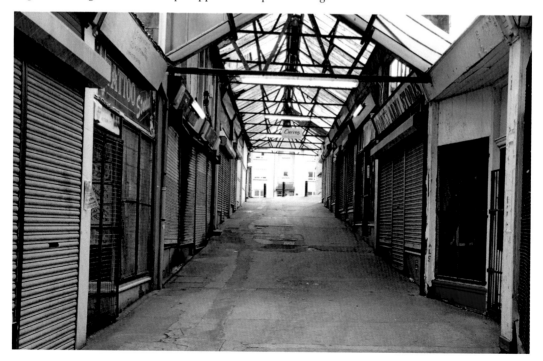

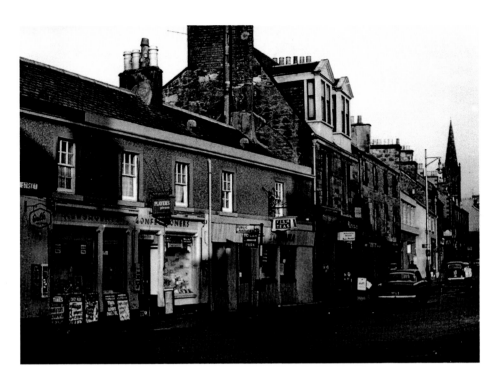

High Street West

The north side of the High Street at the west end has seen little change apart from the usage of the main premises in the images. At one time, it was in dual use as a newsagent, with a tea room or café called the 'Toscana' next door. The total building is now in use as a Cantonese restaurant.

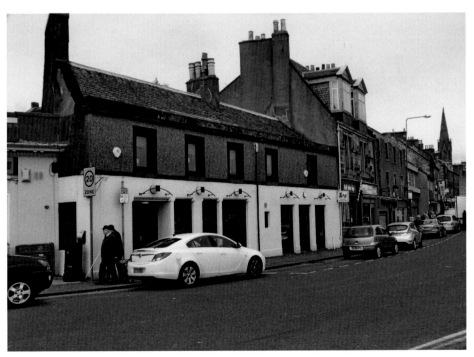

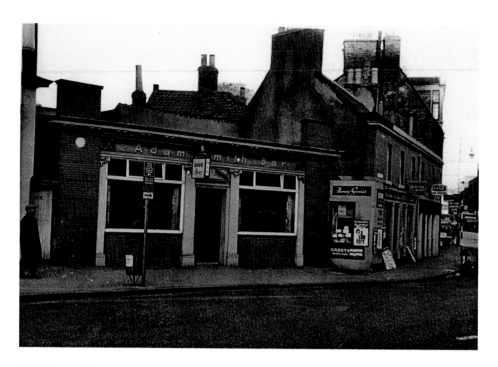

High Street West

Still on the same side of the High Street, and 'next door' to the previous images, we find this rather quaint little pub named after one of Kirkcaldy's famous sons – the Adam Smith Bar. This is another building that has been refurbished for use in the fast food industry, in this case as a Chinese takeaway.

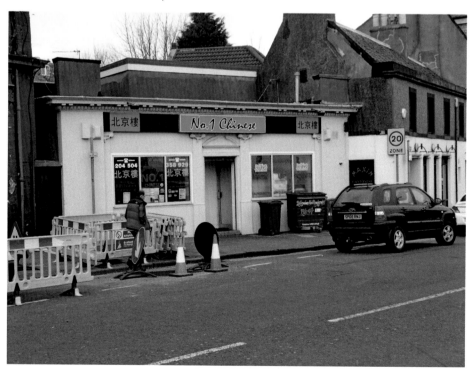

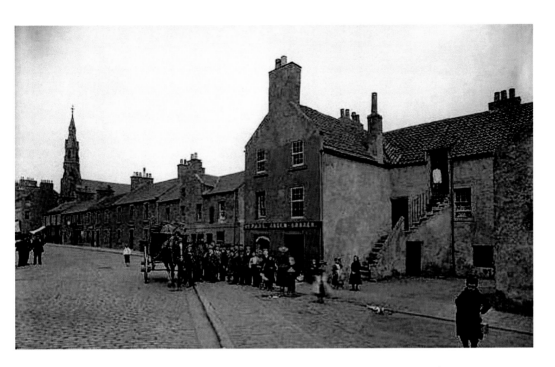

High Street West

Looking at the south side of the west end of the High Street, we see a scene much altered when compared to today's view. The old image dates from the pre-tramcar days as there are no tramlines on show. The tower of Abbotsrood Church is no longer with us either. The buildings with their outside stairs and street water dispensers have all disappeared too, although the road still retains its bend.

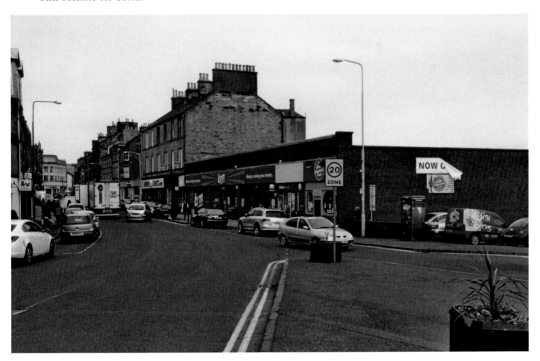

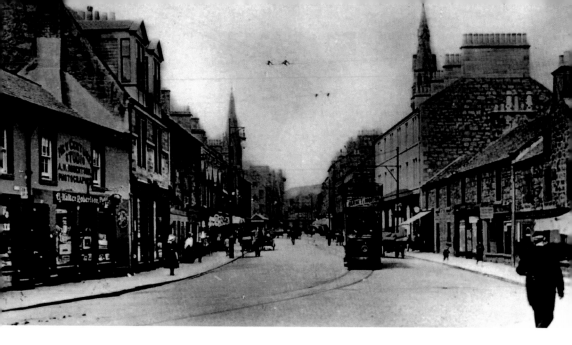

High Street West

A more general view of the west end showing the buildings on the right (the south side) that replaced the older row as described and shown in the previous scene. Even though 100 years old, Kirkcaldy is still instantly recognisable in the older image which shows one of the old Corporation tramcars heading to its terminus at Linktown. It will be noted that the buildings on the south side have been replaced yet again from the previous images.

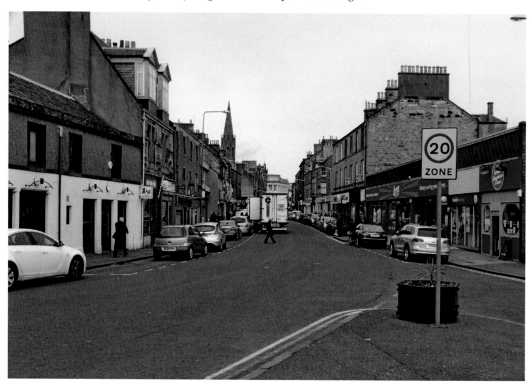

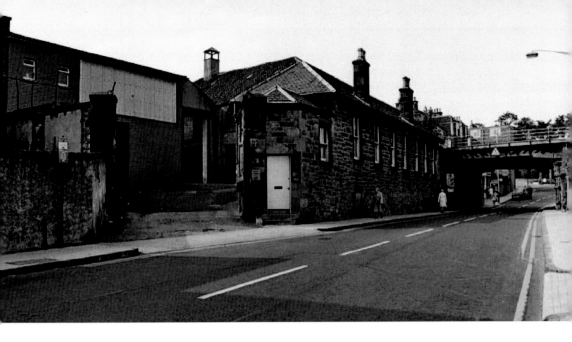

Nicol Street

Apart from the actual road itself, everything else between the old and recent photographs has either been changed or replaced. The factory has been replaced by a row of houses whilst the steel-framed railway bridge has been recently replaced by a newer concrete version.

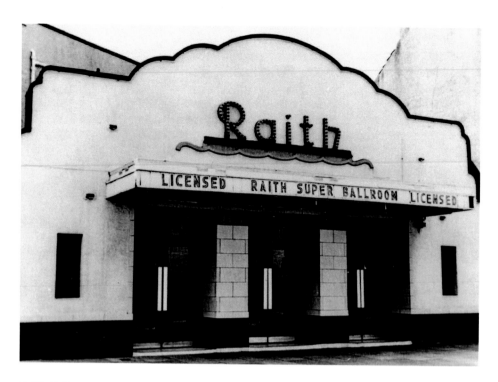

Raith Ballroom

Originally opened as a cinema in 1938 with a classic art deco style frontage, it later became a ballroom in 1974 and later still, a bingo hall. It was the original chosen venue for use on a short tour in 1963 by The Beatles. The venue was later changed to the Carlton at Park Road. It has been used as a church in recent times.

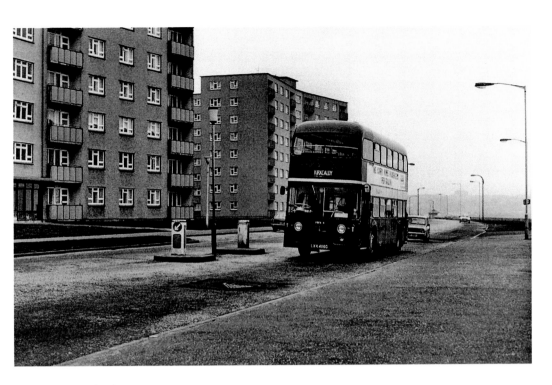

Promenade Flats

These flats, built in the 1950s, have undergone a facelift between the dates the two images were taken. The windows and balconies have been updated at some point, and the forecourt areas are much more pleasant with the introduction of the various planted shrubbery. The road layout has been enhanced too, and is now more clearly lined out.

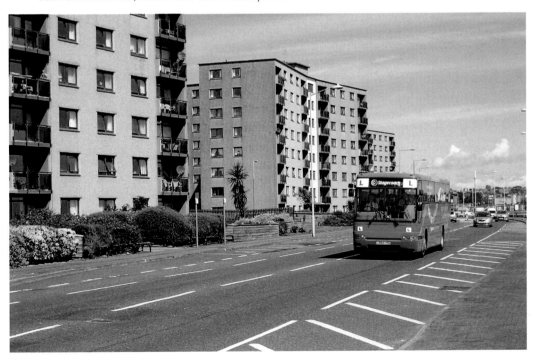

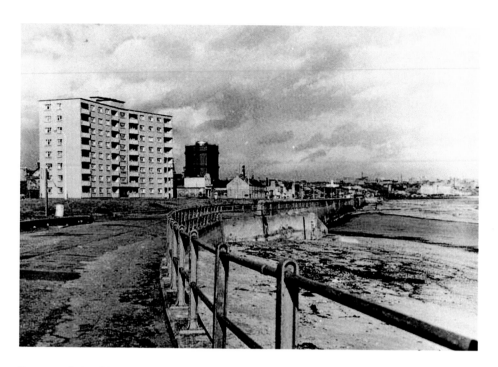

Promenade Looking East

The west end of the promenade looking east is shown here, and the most immediate change is that the gas tank has been removed. It has opened up the general view a bit better looking towards the town. The distant skyline looks similar, but many changes have taken place regarding the various buildings.

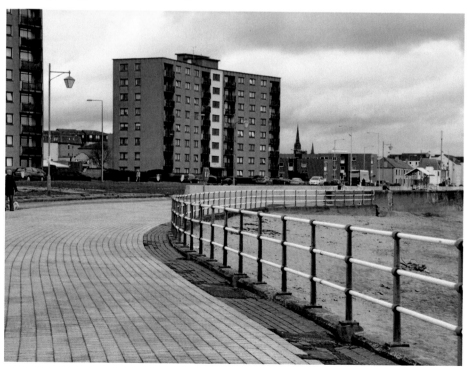

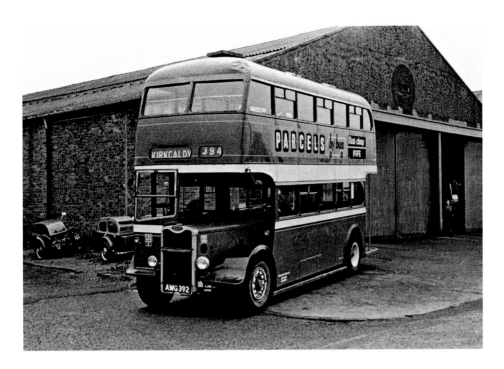

Bus Depot

The head office for Fife's buses was in Kirkcaldy, across the road from the bus depot. The depot closed in 2004 due to its close proximity to the sea and the eroding coastal effect on the rear depot wall. Buses can still be seen in the depot area, as they are taken to the VOSA station up Park Road from here. A large variety of vehicles could always be seen in Kirkcaldy depot.

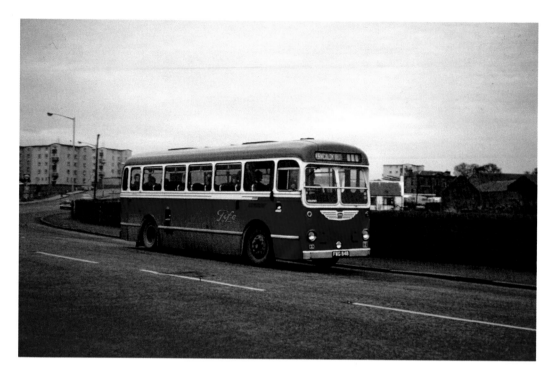

Bus Depot

These views are taken from just outside the (former) bus depot at the west end of the Promenade. The old image shows a Bristol single-deck bus travelling down towards the depot in 1968 from the Invertiel direction. They show the differences in the various buildings looking up towards Invertiel. The flats remain untouched in the distance; the difference being in the foreground with the erection of a new paint shop, which itself is now closed, for the former bus depot.

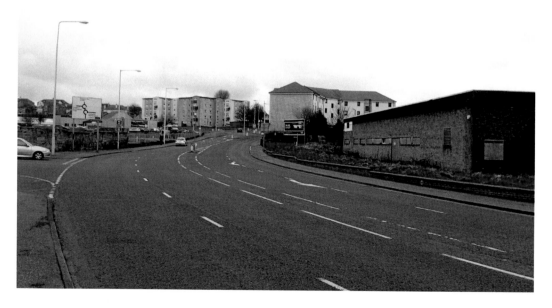

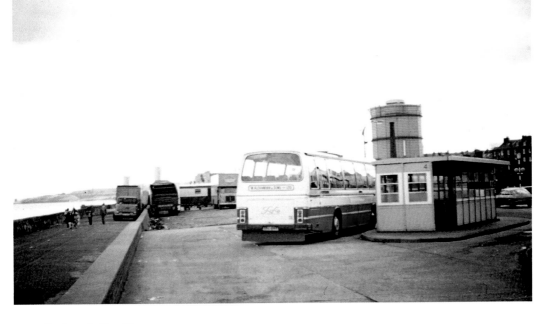

Esplanade Bus Stance

Thirty-four years separate the two views taken at the back of the Esplanade bus stance looking west towards Seafield. Two landmarks in the older image are now consigned to history – the old gas tank and the twin towers at Seafield colliery. Some of the vehicles belonging to the showmen attending the Links Market can be seen at the fair's eastern limit near the bus stance. The former bus stance is now a car park area.

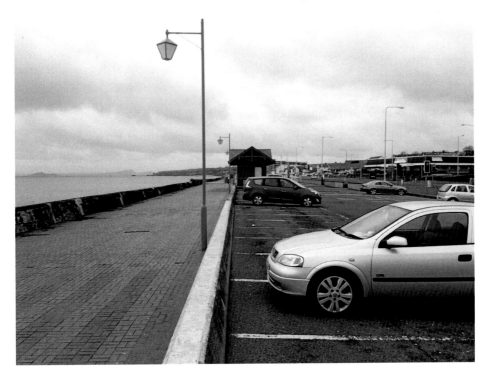

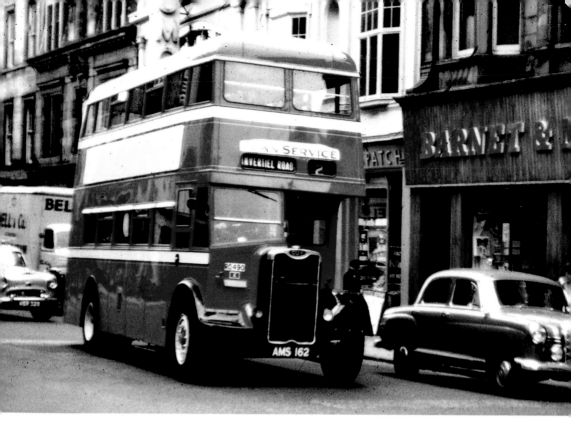

Town Service Bus

Kirkcaldy had dedicated buses for use on its town services. These buses carried the 'Town Service' legend above the destination display area, as shown in this image of one of the town's Guy Arab buses. This was painted onto some vehicles, but others had brackets fitted to carry it on a painted board if needed.

Also by Walter Burt

- *Fife Buses* 978-1-4456-0992-8
- *Kirkcaldy & Central Fife's Trams & Buses* 978-1-4456-1140-2
- *Dunfermline & West Fife's Trams & Buses* 978-1-4456-1147-1
- *St Andrews & North-East Fife's Buses* 978-1-4456-1648-3